*Accalia and the Swamp Monster*

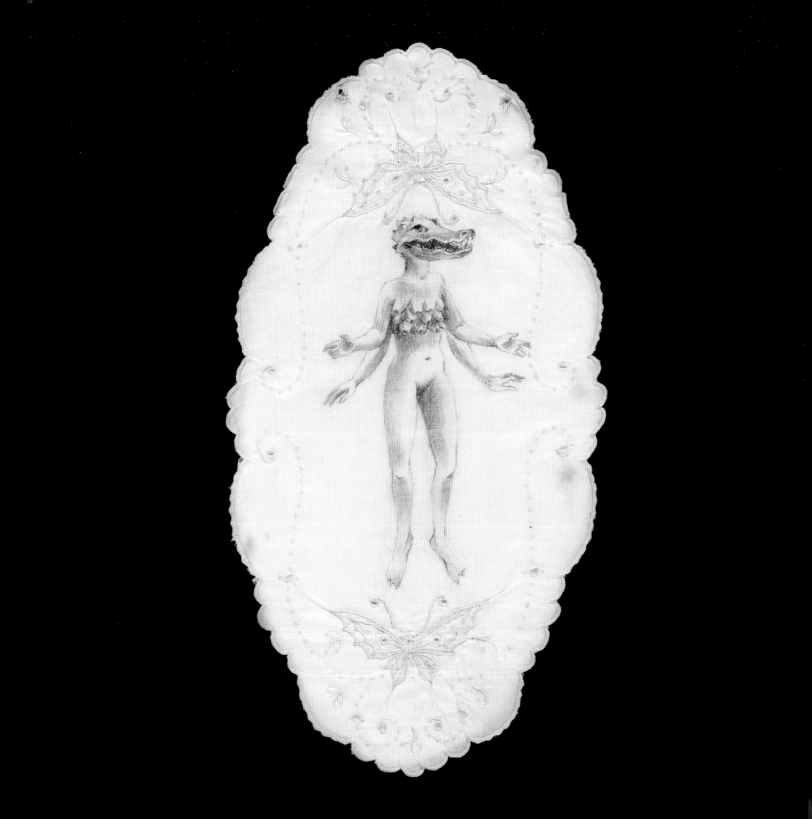

# Accalia and the Swamp Monster

KELLI SCOTT KELLEY

Louisiana State University Press )(( Baton Rouge

Published with the assistance of the Atlas Grant.

Published by Louisiana State University Press
Copyright © 2014 by Louisiana State University Press
All rights reserved
Manufactured in China
First printing

*Designer:* Michelle A. Neustrom
*Typeface:* Livory
*Printer and binder:* Everbest Printing Co. through Four Colour Imports, Ltd.,
  Louisville, Kentucky

*Library of Congress Cataloging-in-Publication Data*
Kelley, Kelli Scott, 1961–
    Accalia and the Swamp Monster / Kelli Scott Kelley.
      pages cm
    ISBN 978-0-8071-5513-4 (coth : alk. paper) — ISBN 978-0-8071-5514-1
(pdf) — ISBN 978-0-8071-5515-8 (epub) — ISBN 978-0-8071-5516-5 (mobi)
1.  Louisiana—Fiction. 2.  Fairy tales.  I. Title.
  PS3611.E44325A65 2014
  813'.6—dc23
                                        2013030631

# Contents

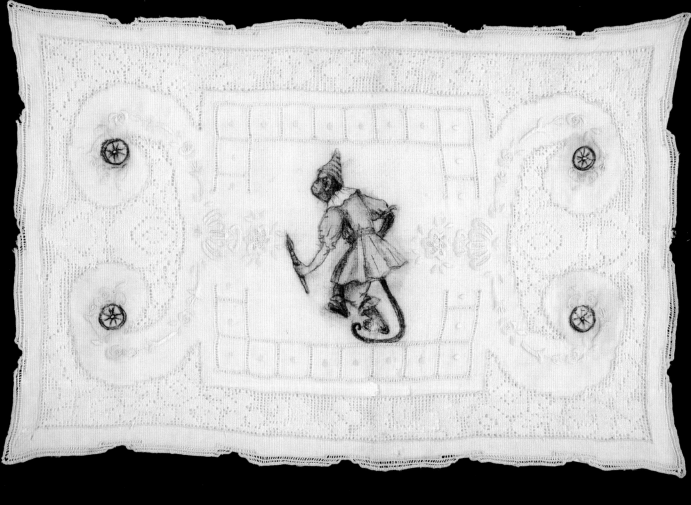

# Author's Note

In 2007, I traveled throughout Italy to study Early Renaissance image cycles. This sabbatical excursion left me curious about the idea of writing my own mythological narrative as a starting point for a body of artwork. Inspired by my autobiography and dreams, *Accalia and the Swamp Monster* is the result of those musings. The artworks, which were inspired by the tale, are mixed-media paintings executed on repurposed antique linens. The aged fabrics reference traditional women's handicrafts and provided a means for me to make the pieces in an ecologically conscious way.

# *Accalia* and the
# *Swamp Monster*

Once upon a time, in a cottage in a faraway land, dwelled three sisters. Accalia, the eldest sister, was dainty and pretty. However, in place of a young woman's head, hers was that of a dog with two faces. The silky fur covering her head and wolflike snouts was dappled silver and charcoal gray. One face was kind and meek, the other gloomy and cantankerous.

Her two younger sisters, Lucilla and Lunetta, were conjoined twins, fused below the waist. They always wore a dress with form-fitting bodices, trying to accentuate their shapely upper bodies. Their shared parts were kept hidden by a full skirt which dragged the ground. They kept their blond hair braided into four pigtails which swayed back and forth as they moved.

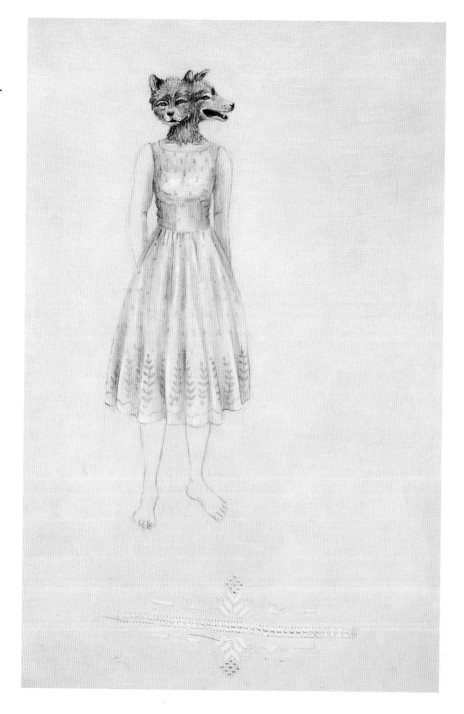

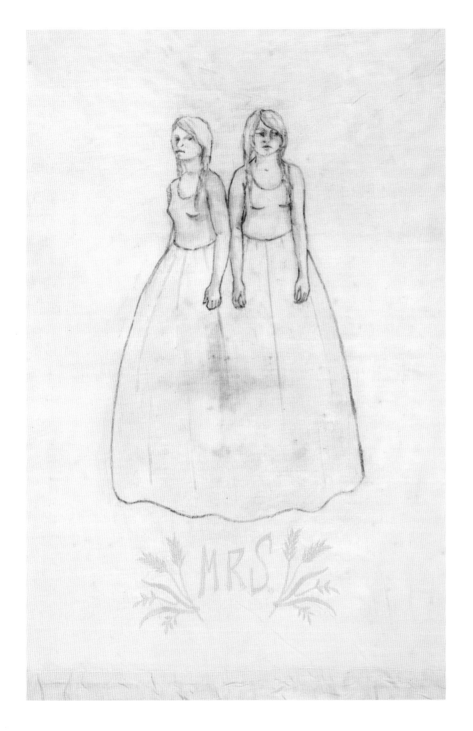

Together the three sisters took care of their sickly father, who was too weakened by regret to care for himself. He stayed night and day under a table in the corner of the kitchen, within earshot of his daughters' constant toils. He was so absorbed in his own misery that he hardly noticed them.

On top of the table lived their mother, a winged lioness. She loved her daughters dearly, but she had become consumed by a ferocious heartache brought about by their father's many deceptions. She kept vigil over him, ready to pounce should he come out from his hiding place under the table.

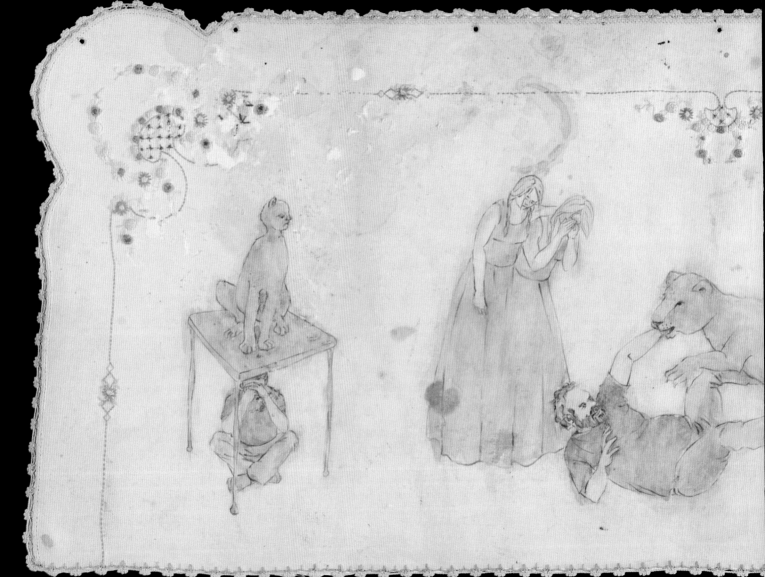

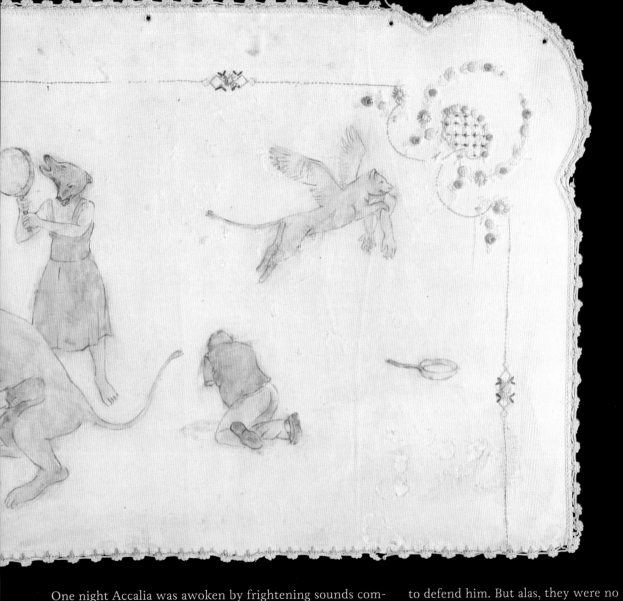

One night Accalia was awoken by frightening sounds coming from the kitchen. She shook her younger sisters awake, and together they ran toward the commotion to find their lioness mother in pursuit of their father. The three sisters frantically grabbed kitchen implements to use as weapons to defend him. But alas, they were no match for their betrayed mother, who savagely tore both of his arms off. Before they could recover their wits, the she-lion was out the window, flying away in the cool night air with their father's arms dangling from her mouth.

As soon as the lioness looked down and saw glints of starlight reflected off of dark water, she let go of the severed arms. She then soared away, relieved of her burden. Meanwhile, the arms tumbled through the air, catching on twigs, moss, and vines as they made their way into the swamp. Breaking the water's surface, they slowly began to sink. Beneath the muddy bottom slumbered an ancient creature. Drawn by the smell of human blood, she floated up from the depths and greedily swallowed the father's arms whole. Then she swam back down through the water to her soft mud bed.

The eldest sister helped their father back into his cave under the table, where she devotedly dressed his wounds. The lioness was gone, but now her father was left completely helpless without his arms. He wept and wept for the loss of his arms. The two younger sisters, very distraught, clung to one another, crying big puddles of tears. The eldest sister placed bowls and pots near her father and sisters, trying to collect their falling tears.

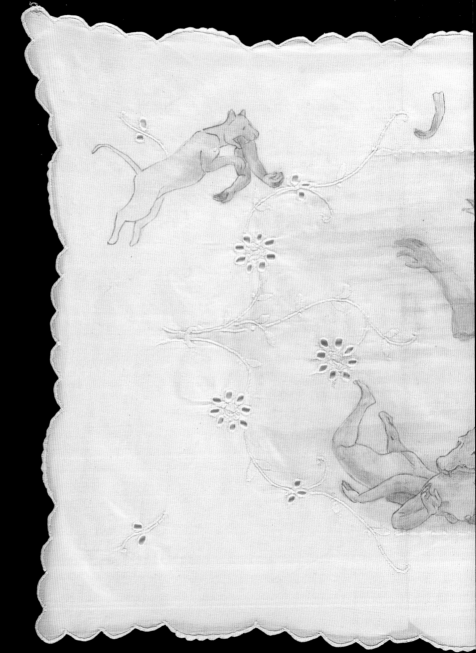

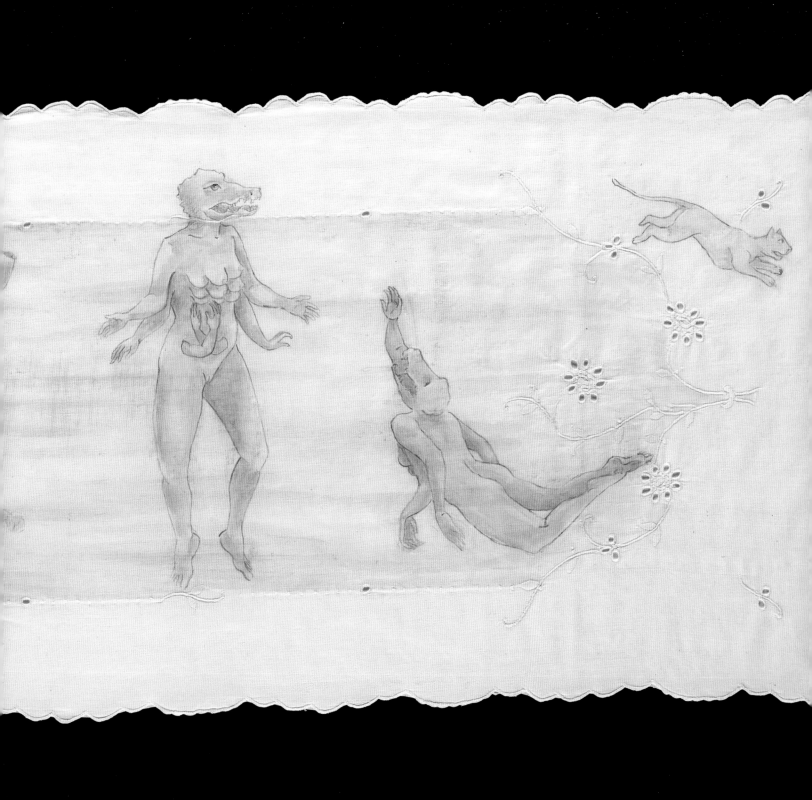

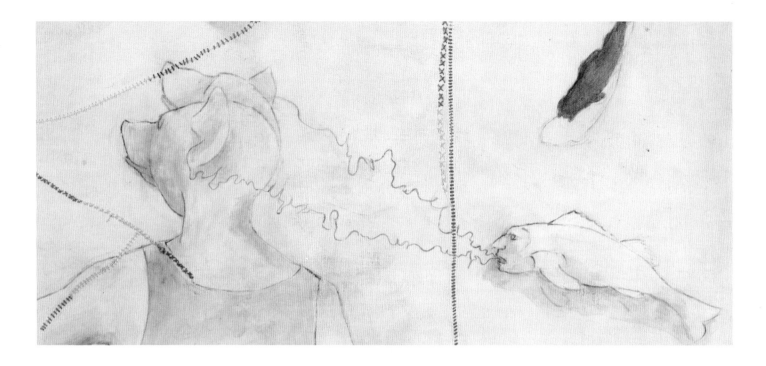

That night, Accalia fell into a deep sleep and dreamed of swimming through murky water among a school of fish and past a large shadowy figure. The next morning she was in the backyard pouring out the overflowing pots of tears, when the haunting cry of a blue heron startled her. Something dropped from its beak and landed with a thud. Lying in the yard was a fish, barely alive and gasping for air. The eldest sister approached the curious sight. She leaned closer to see the shimmering orange and green scales and noticed that the fish's mouth was moving and emitting a sound. As she leaned in even closer, she realized the fish was speaking.

He said, "Sister with two dog faces, you must take a journey into the swamp to reclaim your father's arms. Find the old fisherman and he will guide you. Now, take my body over to the stone at the foot of the old crepe myrtle. Buried under the stone you will find a box. Replace the object inside with my remains and bury me there."

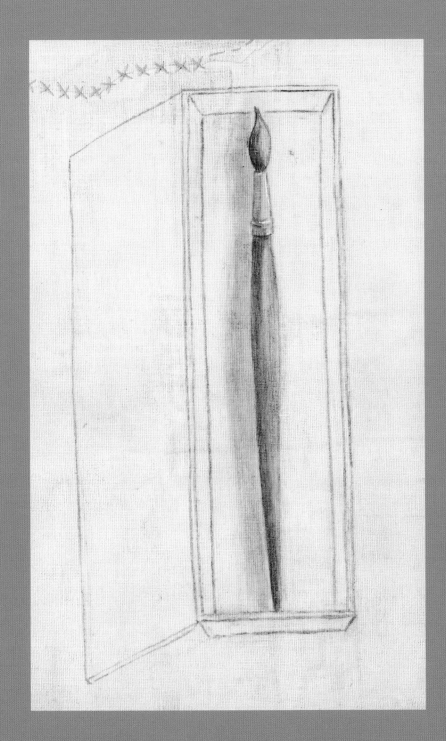

Then Accalia noticed the light had left his eye, so she picked up the dead fish and did as he had instructed. The earth under the stone was soft and easy to dig. Before long her fingertips bumped something hard and as more dirt was removed, she could make out a plain wooden box. She pulled it up from the ground, dusted it off, and pried it open. Inside was a paintbrush with an elongated pale-blue handle and amber-colored bristles that came to a perfect point. When she picked up the marvelous object she felt a pleasant tingling sensation that ran up her arm and through her body. With the bristles facing downward, she pushed the paintbrush up through her dress belt at her hip, keeping it safe, while she finished her task. She laid the fish to rest in the box, buried him, and replaced the stone.

As often occurred, an argument ensued between the eldest sister's two faces. The sweet side encouraged her to have faith in herself and urged her to go search for her father's arms, pointing out her cleverness, endurance, and inner strength. The brooding face bared its teeth and reminded the eldest sister of her weakness and fear, describing the dangers she would face and the futility of the task. She stood for a long while in the yard, feeling the moist summer breeze as it blew through the fur on her faces, her canine snouts savoring the scents wafting on the air. Then she remembered the paintbrush and took it from her belt to examine it more carefully. Again, the instant she touched it, she felt a tingling sensation and a spark of energy coursed up her arm. She grasped the handle and the brush began to tremble in her hand. She hesitantly let go of her apprehension and allowed it to move. In the air before her, colors emerged from the tip of the bristles as it conjured an image. When the painting was complete her arm dropped to her side. It was as if another reality hovered in the air. The painting had soft edges which blended into the scenery of her own backyard. However, the suspended image depicted an unfamiliar landscape. Then it occurred to her that it may be showing the way to the old fisherman. So, with that, the girl with the two dog faces set off down the road in search of her father's arms.

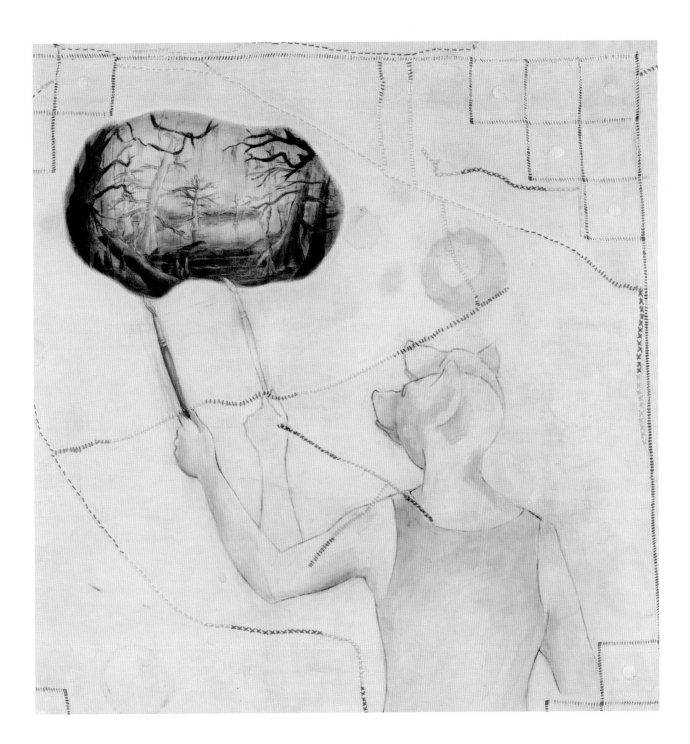

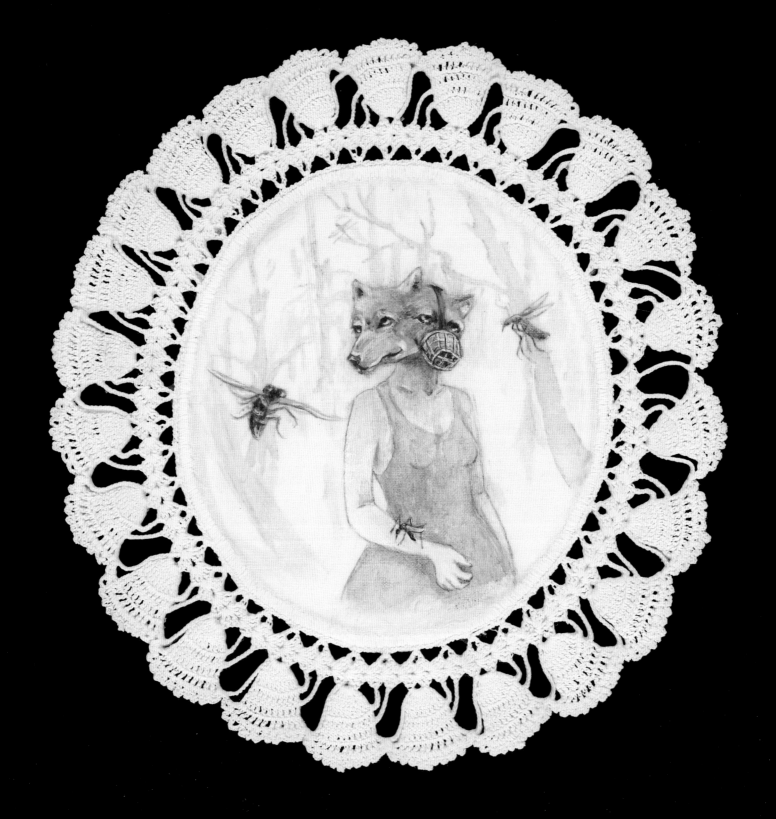

Accalia walked on and on, her two faces silent and grim, until finally the landscape unfolding in front of her began to look familiar. Up ahead she could see wetlands where trees grew denser, and just as in the painting, she saw a trail off to the side of the road leading into the woods. Her sore, bare feet welcomed the cool dirt path that followed the crumbling paved road she had traveled so far. As she entered the swamp, all of her senses came alive. Hungry mosquitoes swarmed around her head. Frogs and cicadas fought for her attention. The air felt humid and impenetrable. Visible all around, cypress knees, reminiscent of gnarled hunched figures, emerged from florescent green algae. From the sky above she heard a screeching call, and shading her eyes, she spotted the blue heron. The primeval bird seemed to be leading the way. Billowing gray moss grazed her shoulders as she followed the path deeper into the watery forest.

The heron swooped down just over her head and flew ahead as the trail suddenly widened, revealing a still bayou. Floating out in the water in a weathered pirogue a peculiar-looking old man sat slumped over a small work bench. The heron landed in the boat beside the man who was intensely absorbed in a task. As she got closer she noticed that his face was reminiscent of the fish from her yard. She rubbed her eyes, looked again, and saw an old man with tangled white hair and beard. Accalia approached slowly.

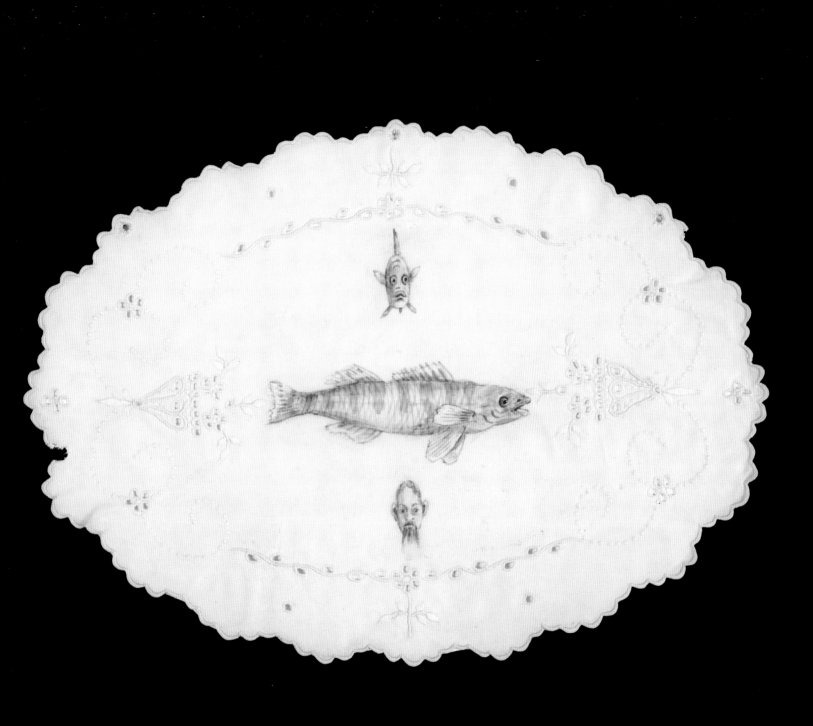

She stood watching him for a while, swatting at mosquitoes, until her assertive face tentatively called out, "Are you the fisherman?"

The man never looked up from his work but eventually replied, "Come."

Accalia looked around for a way to get to the boat. Her meek side whining, she stepped cautiously into the water. It was shallow and her feet immediately sank into the soft ground. Slimy mud squished between her toes as she made her way to the boat and stood next to it, her dress grazing the top of the water, fish softly nibbling at her ankles. She became transfixed by the fisherman's huge weathered hands as they adeptly continued their labor, surrounded by curious tiny gadgets. He was meticulously creating fishing lures, each one unique and beautiful. The eldest sister was suddenly drawn by a sparkle of light reflected off of an intricate object. A glass vial about three inches long was set into a design of delicate silver strands which held it into place. On one end dangled a piece of wire sprouting three sharply pointed hooks, and at the other end was a wire loop for tying fishing line.

"What a pretty lure," her sweet side remarked.

For the first time the old fisherman looked up at the young woman. Then he picked up the special lure and wrapped it in a piece of cloth. "Take this, child, to the ape-oracle. She will help you." With that, his gaze returned to his work.

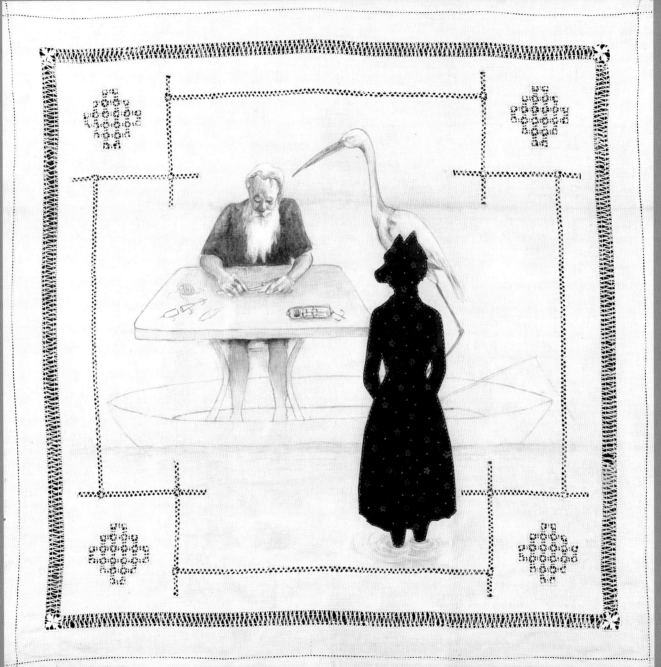

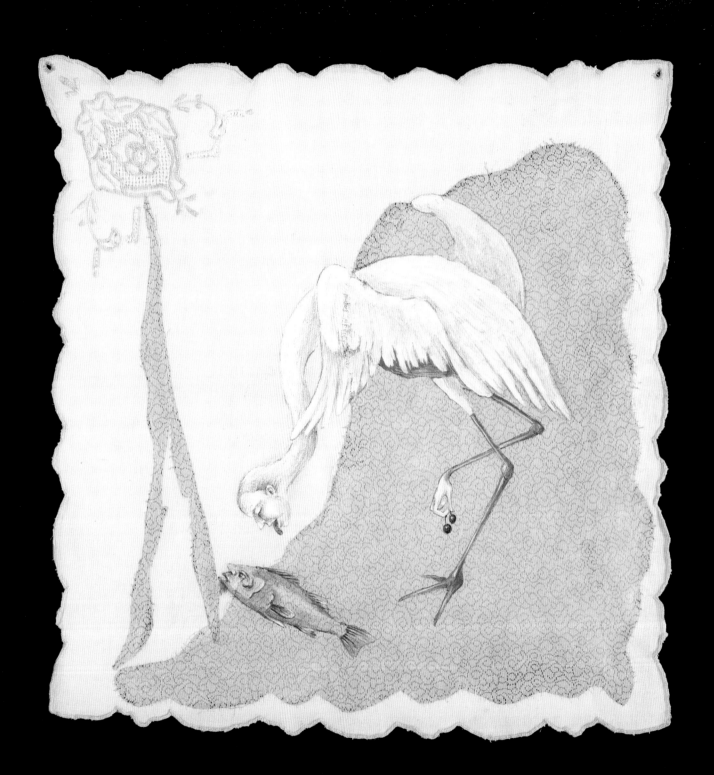

The eldest sister looked down at the bundle lying in her hand and wondered what to do next. She became aware of the scenery surrounding her. The landscape was beautiful and haunting. Amid the lush, overgrown foliage she noticed floating debris. A few feet away Accalia recognized a submerged pirogue, the bow poking up out of the water. Delicately she placed the lure in her dress pocket and began the painstaking work of recovering the sunken boat. The blue heron flew over to assist, pulling on her belt with his beak, giving her more leverage. Finally it began to emerge. Using a tin can bobbing nearby, she bailed the remaining water before climbing in. After disappearing for a while, the heron returned with a worn-looking paddle and dropped it at her feet. The pirogue gently drifted. The big gray bird flew in circles overhead, and the sister with the two furry faces sat panting and contemplating her next move.

Remembering the paintbrush, she pulled it from her belt and once more felt a pleasant surge. This time she welcomed the queer sensation. She relaxed and began to paint a picture in the air, hoping for some guidance. The composition that emerged portrayed an arched white bridge.

The heron turned and began to fly toward a tributary that led further into the swamp. The eldest sister redirected the little boat and followed her companion toward her destination. The forest grew denser, and when it became too difficult to navigate the pirogue among the cypress knees and tree stumps, she abandoned it and set out on land. The forest was alive with the sounds of creatures moving through the trees and water. There was a trail, but it became harder to discern. Spanish moss formed a ghostlike canopy all around her. It sagged from tree limbs and vines, swaying in the gentle breeze. Up ahead she saw a whitish form and as she drew closer, it became apparent that it was the bridge from the painting. When she arrived the heron was perched on the railing, waiting.

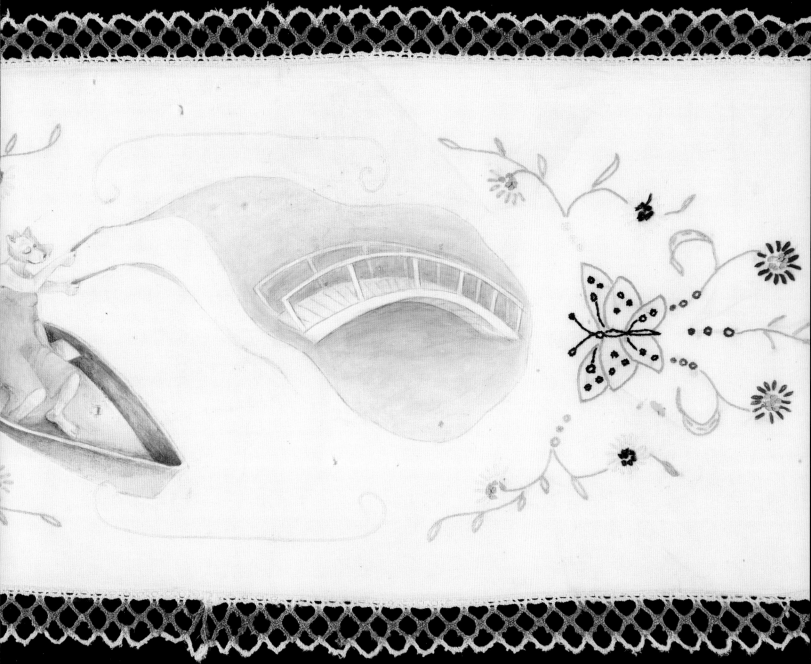

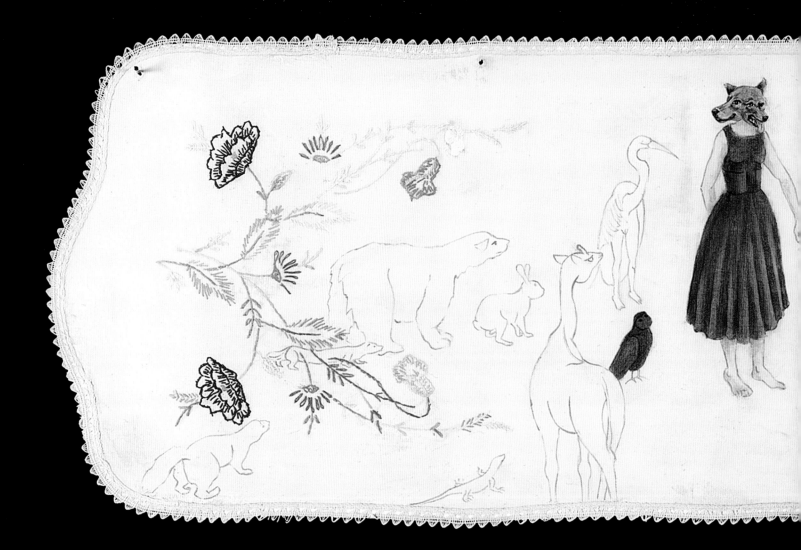

Accalia held tightly to the handrail, hesitantly crossing over the rickety bridge, which creaked under her weight. After crossing the bridge, she found herself on a little island and the fur on the back of her neck bristled, her canine senses becoming intensely aware. Her tenacious side growled threateningly. The gentle face whined, but the blue heron flew on, so she reluctantly followed, spying wild things of all kinds hidden in the tangled foliage. Cautiously animals began to show themselves: deer, snakes, rabbits, and bears as well as more exotic animals such as lions and kangaroos. She also spied extraordinary hybrid animals, but they were elusive and stayed hidden. The diverse species seemed to live in harmony, and in their eyes she recognized intelligence. Before she knew it, she was surrounded but felt

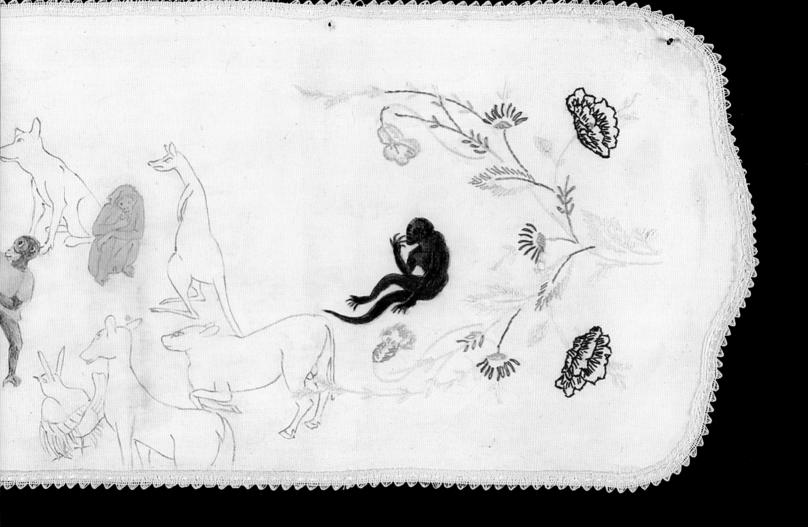

curiously safe. All at once a humanlike ape creature leapt
out of a tree and landed at her feet. It appeared to be a
young male. She was surprised when he reached out and
took her hand, urging her farther down the path. The other
animals moved aside, allowing them to pass, and then fol-
lowed behind.

The ape-boy led her to a clearing, where she saw a strange tableau. In the center of the clearing was a beautiful woman with apelike features wearing a gown made from a multitude of animal skins. The ape-woman was perched high off the ground on a seat atop a platform with slatted planks through which a steamy mist penetrated and wafted up toward her. As they approached, Accalia observed an opening in the earth under the platform exposing bubbling liquid covered by a frothy film. Dusk was quickly approaching, and in the ensuing darkness purple and blue flames became visible, dancing across the surface of the gaseous material.

The ape-woman's eyes were closed and her lips moved silently. Nudged by the ape-boy, the eldest sister moved forward causing the ape-woman to jolt. Her eyes began to move rapidly back and forth beneath her eyelids.

"What do you wish to know," the ape-woman asked, her voice barely above a whisper.

Accalia was trembling, but her tough side spoke up. "The fisherman sent me. I am seeking my father's arms."

The ape-woman's body swayed, her eyelids fluttered, and after a while she spoke. "Down, down at the bottom of the bog, your father's arms rest in the belly of a great beast." With her eyes still shut, she held out her furry hand. "Hand me the crystal lure."

Accalia fumbled in her pocket for the lure, and after unwrapping it, she stretched up on her tiptoes and placed the shimmering object in the outstretched hand. The ape-woman cupped the lure tightly and held it up close to her heart. Steamy vapors enveloped her while she teetered back and forth. A bluish mist seeped through her fingers. When the mist subsided the ape-woman reached down and handed the lure back to her. Inside the glass vile was now a glowing blue-green liquid. The eldest sister examined it incredulously as the ape-boy led her away. Her dog faces were still looking back toward the ape-woman, who remained in a trancelike state, when suddenly she was startled to hear someone speaking.

She turned to her ape-guide, surprised to see that he was addressing her. "You are tired and hungry, child. Come and eat with us and I will tell you the legend of our swamp monster."

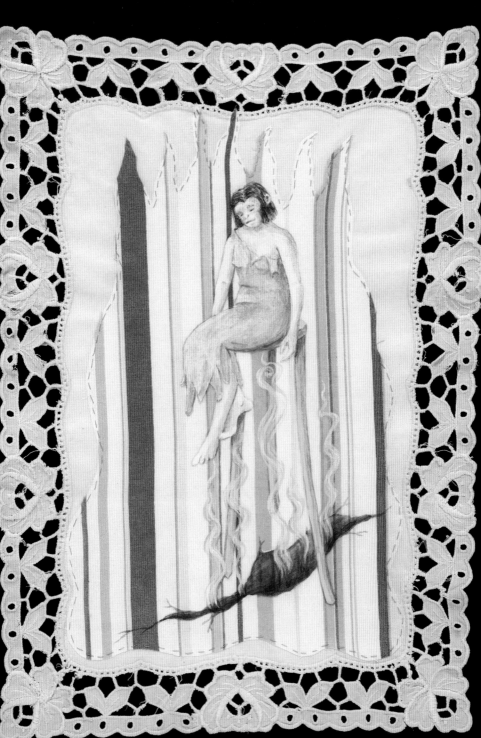

Soon they came to another clearing with a large fire at its center. A menagerie of animals was gathered around it, eating and conversing. As Accalia slowly grew accustomed to the strange scene before her, she realized that she was bleeding. She'd clasped the lure so tightly the hook had pricked her skin. Instinctively she brought her hand to her mouth to stop the flow. In her blood she detected a sweetness, and just then she sensed a disorienting sensation passed through her body. For a moment she became so dizzy that she almost lost her balance. Silence descended on the space. All eyes were focused on the girl with two dog faces. Self-consciously, she composed herself and after the lure was safely wrapped and stowed in her pocket, she sat down. The bleeding had already subsided, the mark barely visible. Still, she pretended to examine her wound, afraid to look up. The ape-boy offered her a piece of cooked fish. Now aware of an intense hunger, she took the food without looking at him and devoured it. Before long the conversations around the fire resumed. Bearing more fish, the ape-boy settled down next to her.

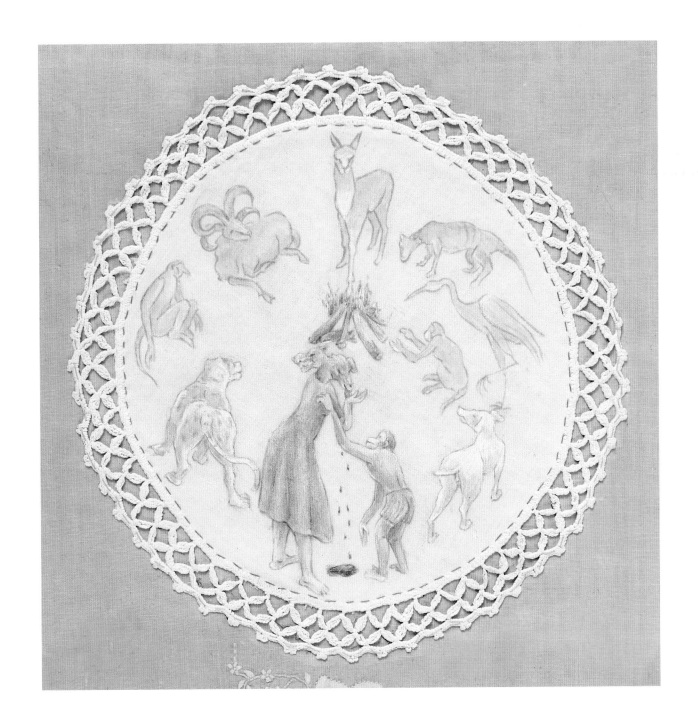

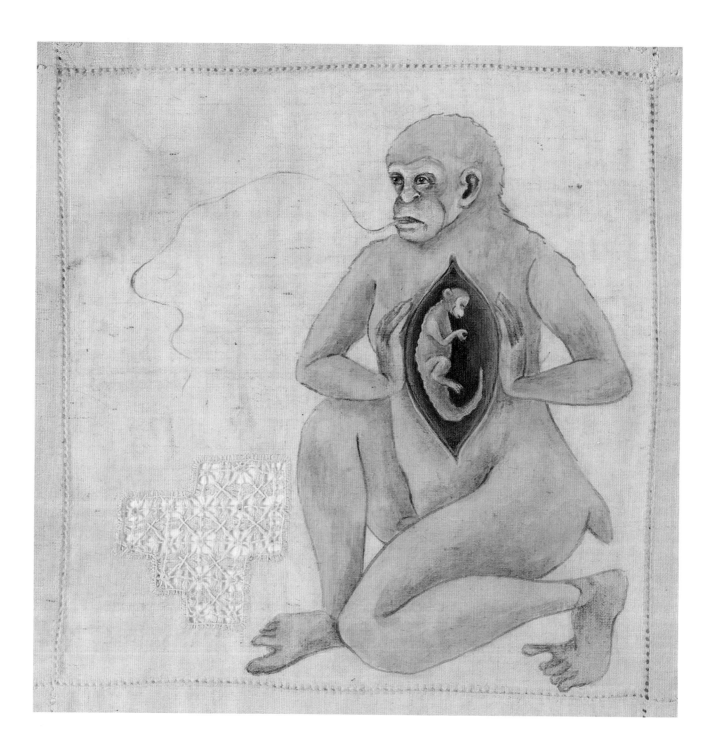

After a while the ape-boy spoke. He began, "Long, long ago . . ." and the other animals stopped what they were doing, eager to hear the familiar story. "A traveling circus was passing nearby when a hurricane came barreling down out of the heavens. Powerful winds and torrential rain tore the carriages to pieces, and the circus animals, frightened by the crashing thunder and lightning, ran in all directions, away from their destroyed cages. Many of the animals died, but our ancestors survived."

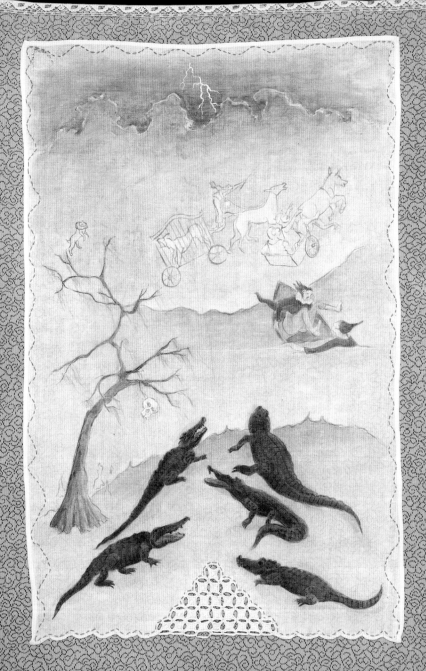

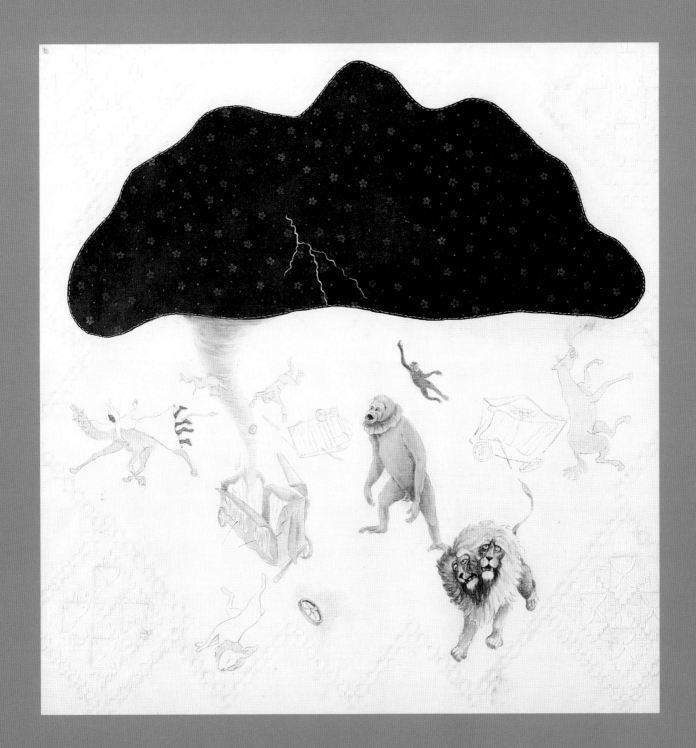

"All the animals were well-trained and very intelligent, but the most renowned were a group of legendary talking apes. These apes were almost human and possessed mysterious powers."

ragged, dirty, shoeless—each with a sugar-loaf straw hat, a Remington rifle of the pattern of 1882, or a brand-new Krag-Jörgensen donated by Uncle Sam, and the inevitable and ever-ready machete swinging in a case of embossed leather on the left hip. They were very young and very old, and were wary, quick-eyed, intelligent for the most part, and in countenance vivacious and rather gentle. There was a little creek next; and, climbing the bank of the other side, I stopped short, with a start, in the road. To the right and on a sloping bank lay eight gray shapes, muffled from head to foot, and I thought of the men I had seen asleep on the deck of the transport at dawn. Only these were rigid, and I should have known that all of them were in their last sleep but one, who lay with his left knee bent and upright, his left elbow thrust from his blanket, and his hand on his heart. He slept like a child.

## Rough Riders' Camp.

Beyond was the camp of the troopers who had taken part in the fight. On one side stood the gun that himself had aimed a Hotchkiss gun in the fight, covered with the sweat and with the passion of battle not quite gone from his face. Across the road soldiers were digging one long grave. Half a mile further, on the top of a ridge, and on a grassy sunlit knoll, was the camp of the rough riders, the rifle pits from which they had driven the Spaniards during the fight, lay another row of muffled shapes, and the road that led down to the hospital a quarter of a mile away, cool-shaded and dappled with sunshine, ran along the edge of the battlefield, and was as pretty, peaceful and romantic as Lovers' Walk now is at White Sulphur.

Here and there the tall grass along the path was pressed flat where a wounded man had lain. In one place the grass was matted and dark red; near by was a blood-stained hat marked with the initials "E. L." Here was the spot where Hamilton Fish fell, the first victim of the fight; there brave young Capron was killed. A passing officer bared his left arm and showed me three places between his wrist and elbow where the skin had merely been blistered by three glancing bullets, as he ran in front of Capron after the latter fell. Farther on lay a dead Spaniard with covered face. A buzzard flapped from the tree over him as we passed beneath. Beyond was the open-air hospital, where were two more rigid human figures, and where the wounded lay.

That night there was a clear sky, a quarter moon and an enveloping mist of stars, but little sleep for any, I imagine, and but restless battle-haunted sleep for all. Next morning followed the burial. Captain Capron was carried back to the coast. The rest were placed side by side in one long, broad

He continued. "The circus animals were terrified by the fierce alligators that ruled these parts, so the apes, with their cunning, bewitched the alligators and befriended them."

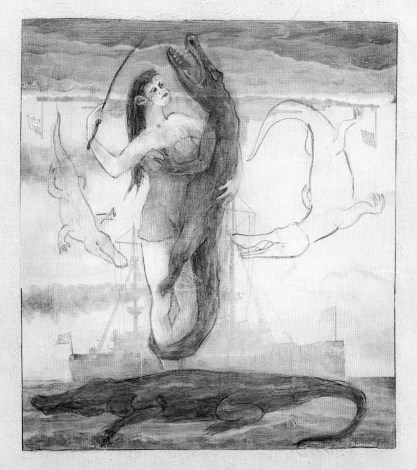

The circus animals were terrified by the
fierce alligators that ruled these parts, so
the apes, with their cunning, bewitched the
alligators and befriended them.

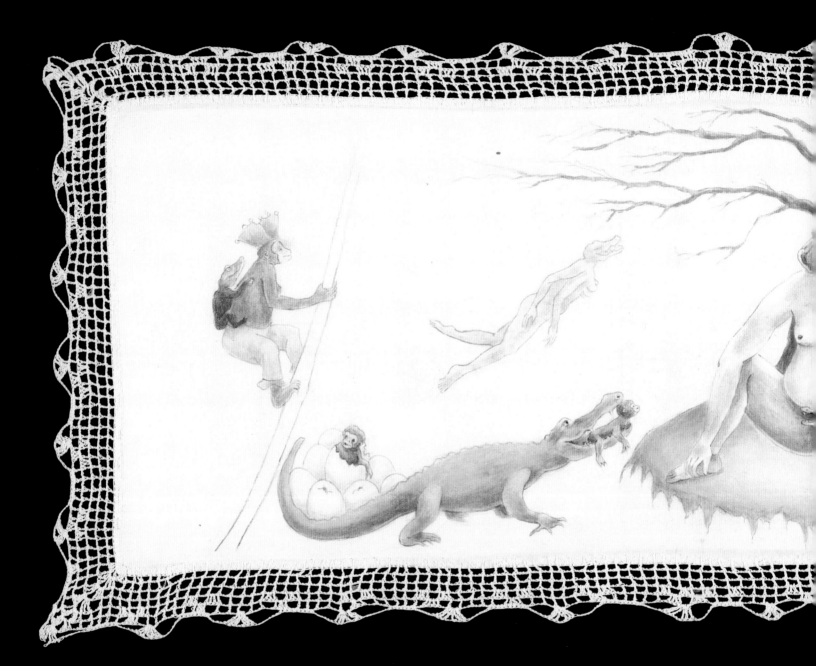

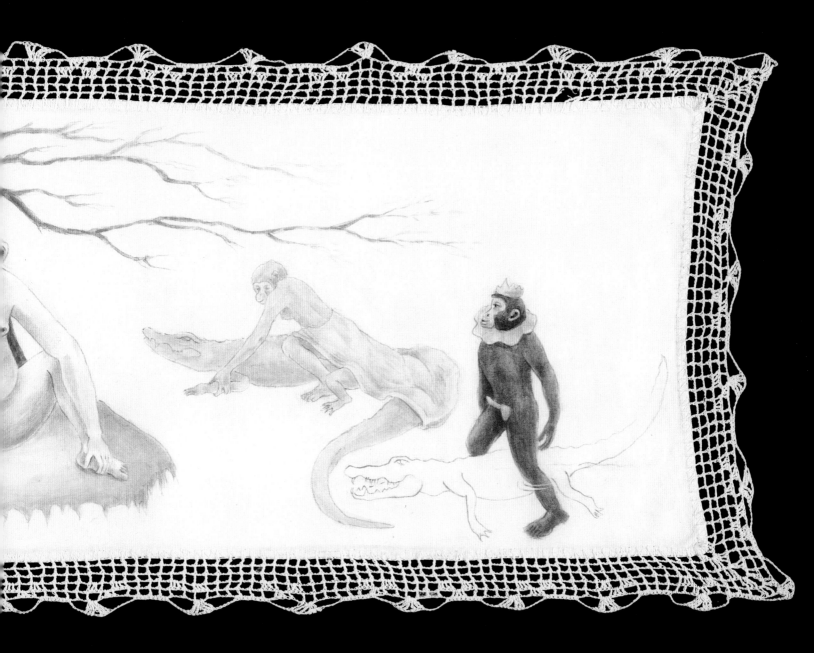

"Eventually, some of them began to breed with the alligators and a new species of alligator-apes evolved."

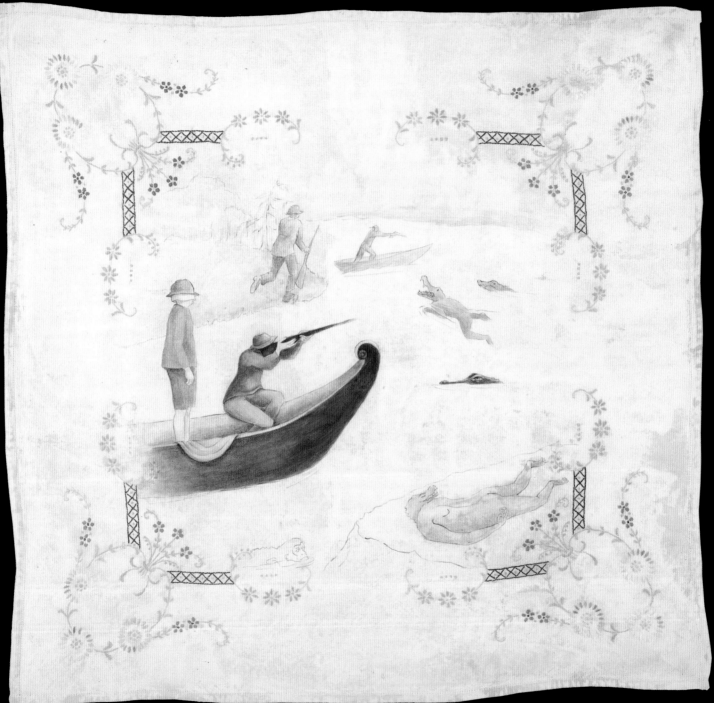

"Over the years, men, believing they were protecting their
families, hunted the hybrid animals close to extinction. As
legend has it, only one of these creatures still exists, the great
mother of them all. She is bereaved and vengeful and lives,
brooding, at the bottom of this swamp."

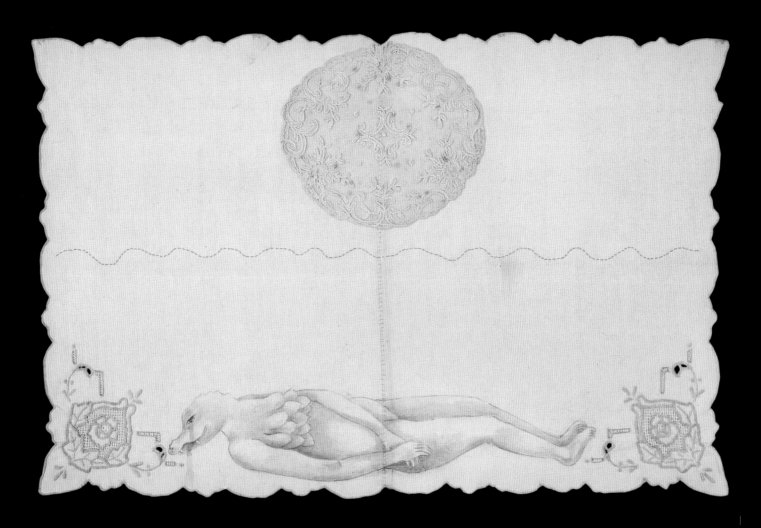

"We live in fear of
her periodic rampages
to our island, when
she surfaces to feast
on the defenseless
inhabitants."

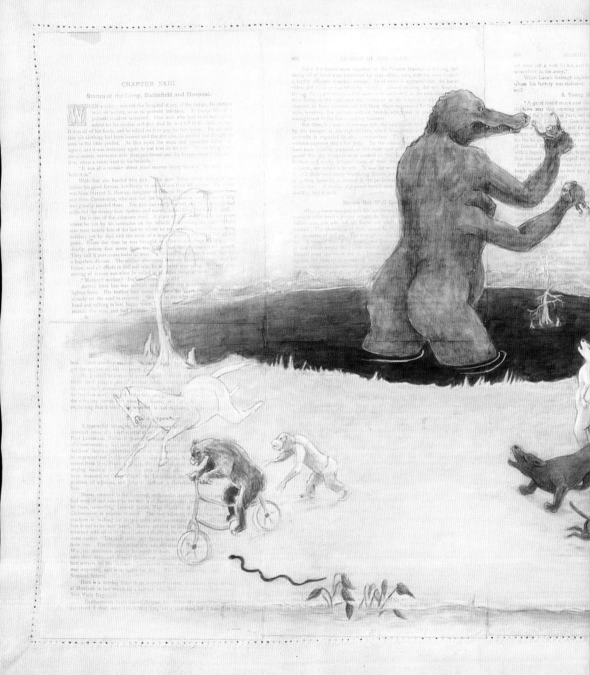

And meanwhile she is only one of
these creatures still exists. The great
Mother of them all. She is bereaved and
vengeful and lives brooding at the
bottom of the swamp. We live
in fear of her periodic rampages
into our island, when she surfaces
to feast on the defense-
less inhabitants

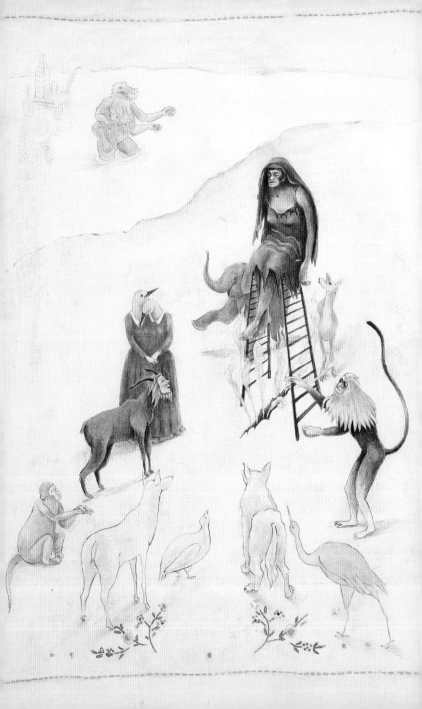

It is only through the ape-oracle's portents that we have avoided being completely wiped out.

She has swallowed your father's arms, and before long, they will be digested, but for now, they remain intact inside her belly."

After a pregnant pause, Accalia's meek side asked in a trembling voice, "But how can I possibly get my father's arms back from that monster?"

By the dim light of the fire even the eldest sister's more aggressive face looked anxious. All of the animals silently awaited his response. She peered around the circle of animals, sensing concern in their eyes. She was suddenly caught off guard when she spotted her mother, the lioness, just before she disappeared among the throng.

"You must rest," said the ape-boy. "Tomorrow is a new day. Come. There is a place for you to sleep up in the trees, where it is safe."

Dazed and weary, she followed him to a grove of ancient cypress trees. Looking up she could see figures draped among the boughs. Because there were so many branches, it was easy to climb the massive tree. Just under the canopy she came upon the blue heron roosting beside a nest cushioned with layers of moss. The eldest sister climbed in. As she drifted off she became aware of a subtle throbbing coming from her hand and remembered her pricked palm.

As morning approached, Accalia tossed and turned, ensnared in a surrealistic dream. She saw her father coming toward her. As he drew closer, he transformed into another being whose dark, captivating eyes entranced and enveloped her. His musky fur-covered body entwined with hers. Then the dream took her out of her body, where she observed herself from a distance. In the blue heron's roosting spot she saw the winged lioness draped over the tree limb, watching over her as she slept in the nest, a normal human woman's head in place of her two dog faces.

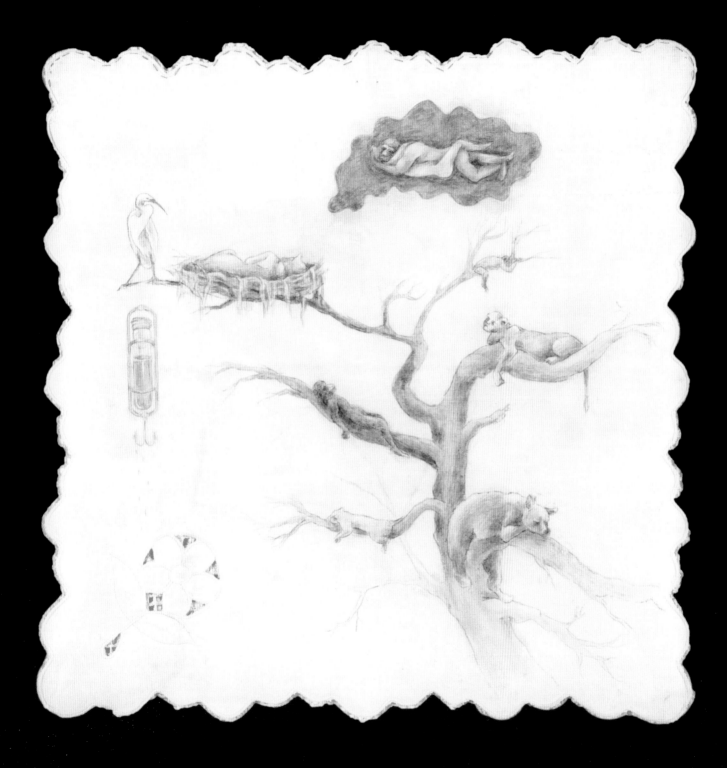

The cry of the blue heron woke her. Accalia bolted up, hoping to find the lioness, but saw only the empty tree branch as she gazed out over the unearthly surroundings. She felt odd. Her stomach was queasy and she was famished. A bit shaky, she made her way down the tree. At the fire, she found a breakfast of delicious sweet potatoes and berries waiting for her. Though she felt better after eating, she couldn't shake the sense that some shift had occurred.

Unsure about the trek ahead, the eldest sister sought solitude, and finding an out-of-the-way tree stump, removed the paintbrush from her belt. Closing her eyes she breathed deeply, surrendered her uncertainty, and giving in to the magic of the brush, commenced to paint. When the painting was complete, the eldest sister sat still as her two dog faces intensely studied her creation.

She was so transfixed that she hadn't noticed the blue heron and ape-boy come up behind her until the ape-boy said, "I've seen that shack in your picture. It's been abandoned for a long time. To get to it you'll have to go further into the woods."

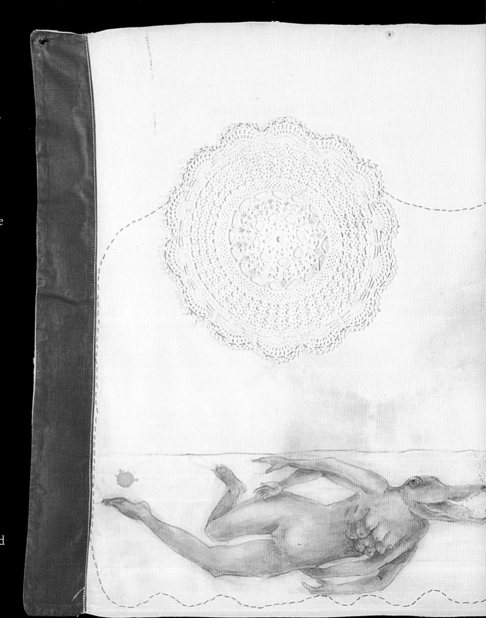

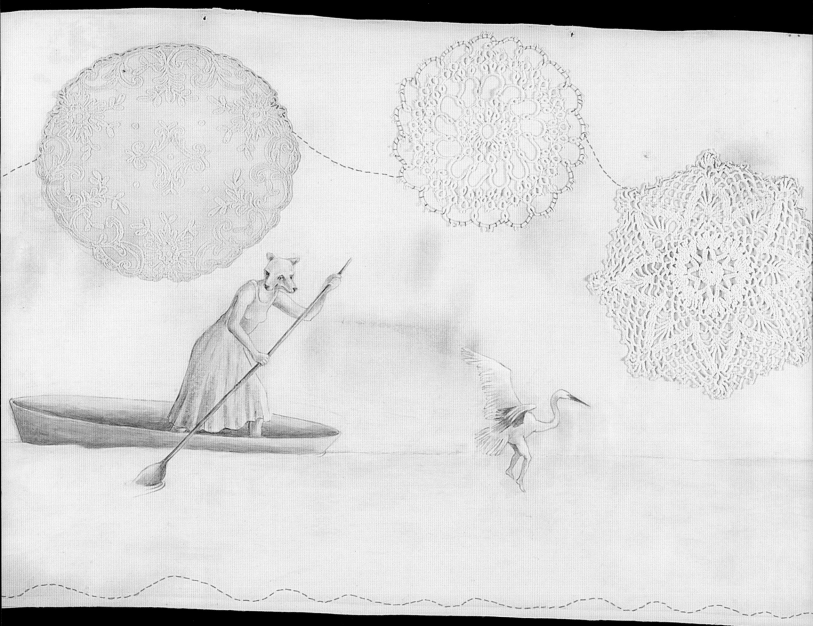

B ut how do I find the creature with my father's arms?" her meek face asked.

"I do not know what lies ahead for you. Listen to what your heart tells you. I have packed some food and water for your journey," he said, gesturing to a parcel tied over the blue heron's back. "You must be off at once. Time is running out!"

Accalia thanked the ape-boy and ran to catch up with the blue heron, who was almost out of sight.

Settled back in the pirogue, with the heron perched on the bow, Accalia found an inlet and rowed deeper into the forest. Throughout the long, muggy day a queer feeling stayed with her, and she noticed that her stomach had begun to swell. While the heron flew off to hunt for fish, the eldest sister sat silently and rested. As the boat floated on the water, she began to think. She contemplated all that had happened since the fish spoke to her in the yard. She thought about the dream from the night before and the

ape-boy's parting words. In a sudden wave of comprehension, she knew.

The pinkish-orange evening sky created a luminous glow through the black silhouetted vines and limbs, and still Accalia rowed on through the tangled floating forest. It was becoming almost impenetrable and the paddling more cumbersome as her belly continued to grow.

Suddenly the heron swooped down and glided over her. Just ahead, barely visible through the foliage, perched high up on stilts, was the shack from the eldest sister's most recent painting. Desperately tired, she pulled the pirogue up to a ladder which descended from the small dilapidated house. As she stepped onto the first rung, it gave way and her foot dipped into the water. She pulled herself up just in time to hear a splash nearby. Glowing pairs of eyes appeared in the water all around. She awkwardly scrambled up the ladder, her pregnant abdomen making it more arduous.

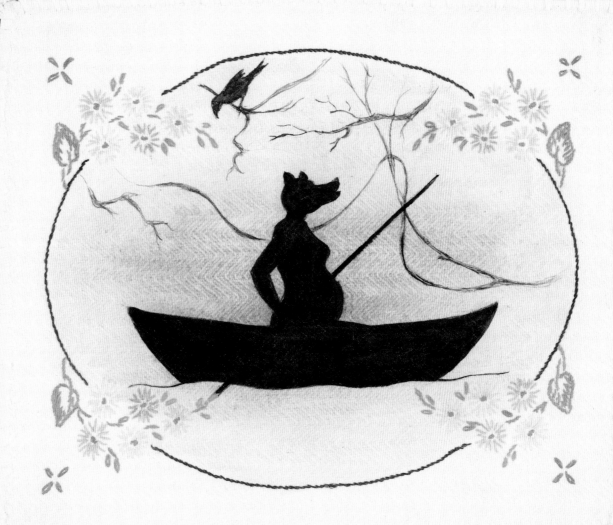

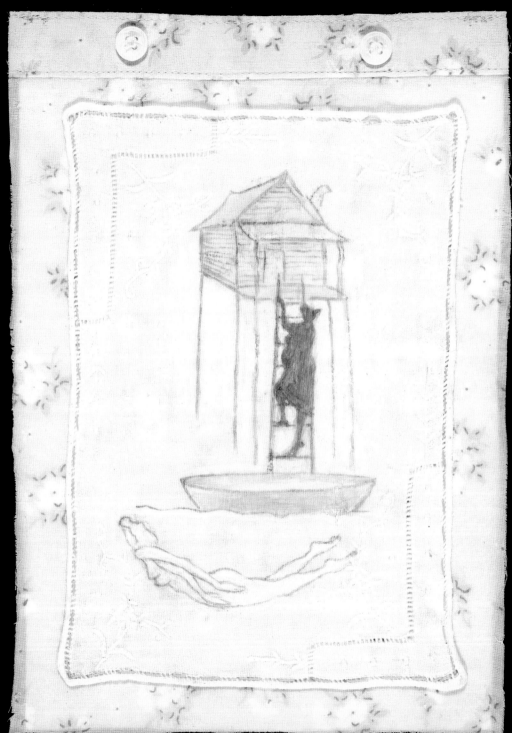

The door to the shack creaked open. Her two faces panting, Accalia waited for her eyes to adjust to the blackness inside. On his impossibly tall, thin legs the blue heron walked in past her and used his beak to push the window shutter open. Orange light from the low-hanging sun seeped in making it possible to discern the bare room. In the center stood a soot-covered wood-burning stove. To the right, under the window, was a table. A coffee pot sat on top of the kitchen counter. In the back-left corner was an iron bed draped with mosquito netting, which hung limply from the ceiling. Accalia waddled in, using her hands to support her lower back, and gratefully collapsed onto the bed. Her blue heron friend pulled the pack off of his back with his elongated beak and offered her some food and water. With some effort, Accailia raised her head up, drank greedily, and after a couple of bites fell back onto the mattress. In less than a moment she was breathing deeply and soundly asleep. The heron drew the mosquito netting around her and flew out the window to roost in a nearby tree.

At day break she awoke to the sound of pounding rain, her body drenched in sweat, to find at her breast a tiny baby boy. However, this was no ordinary baby. His fat cheeks were cherubic and flushed pink, but his body was covered in a downy brown fur and his feet had an apelike appearance. Overwhelmed by powerful emotions, the young mother's cheeks became wet with streaming tears.

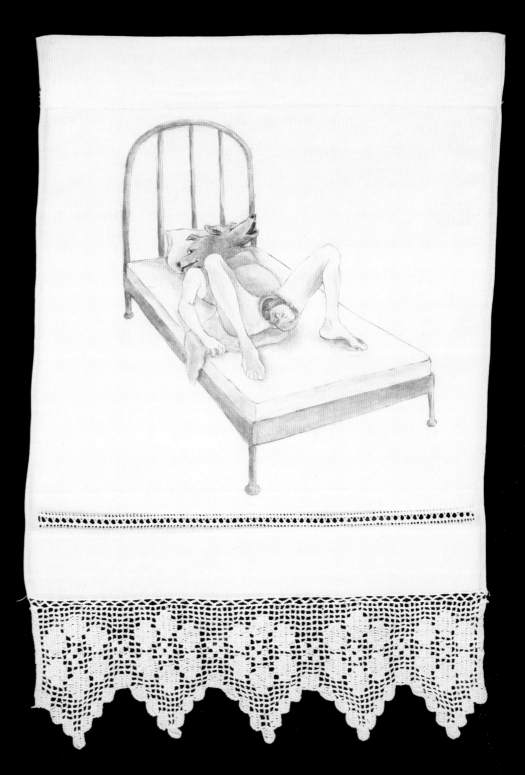

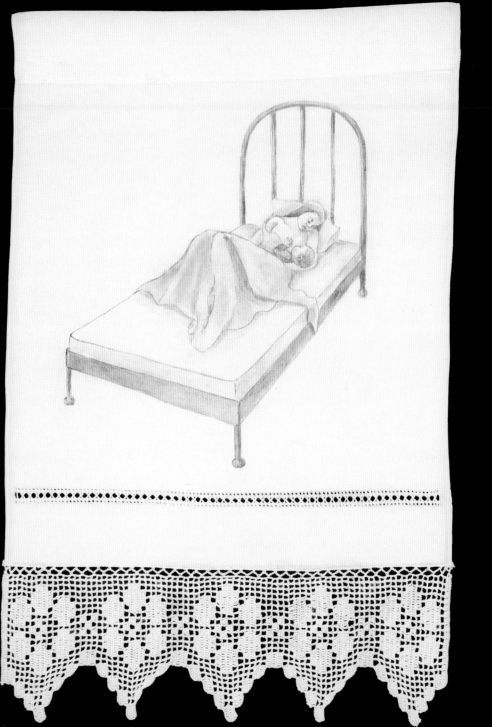

She reached up to brush them away and was shocked to feel smooth human flesh in the place of her furry dog faces. It took a while for her to realize that she couldn't lift her head. It was stuck down at an angle which only allowed her to look upon the face of her baby boy. Years of pressure, exerted by the weight of the conflicted dogs' faces, had forced her true head into that permanently restrained position.

For three days the young mother convalesced beneath the mosquito netting and nursed her baby. Parcels of comforting food from the isle of the ape-oracle were brought to her by her blue heron friend. Day and night the young mother crooned sweet lullabies to her growing baby boy, while unbeknownst to her, the sounds of her singing traveled on the thick, humid air and down into the murky water, rousing the swamp monster. Seduced by the beacon of the young mother's enchanted melodies, the beast swam up toward the shack in the heart of the boggy forest. There she stayed hidden beneath the water, consoled by the lullabies.

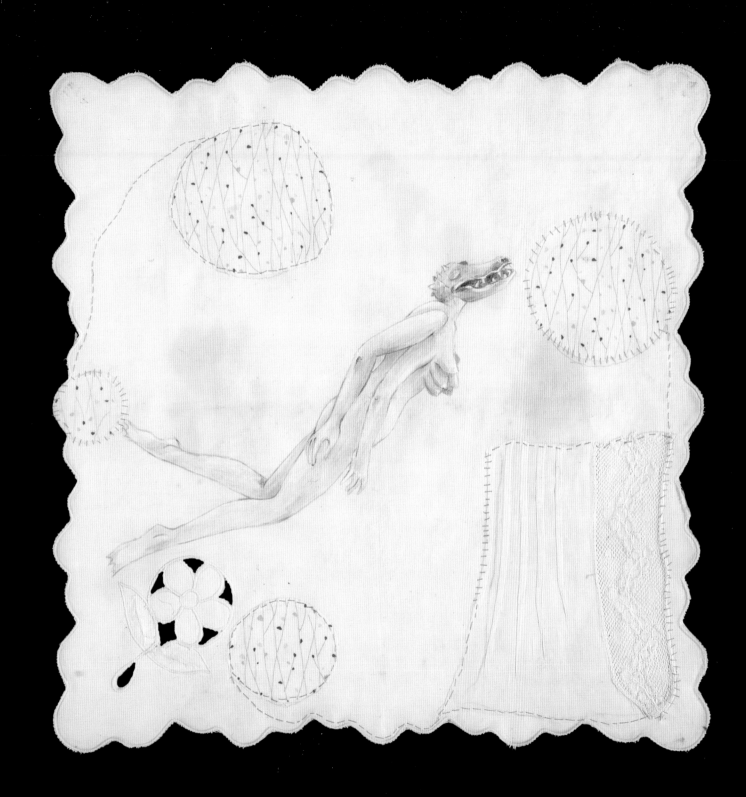

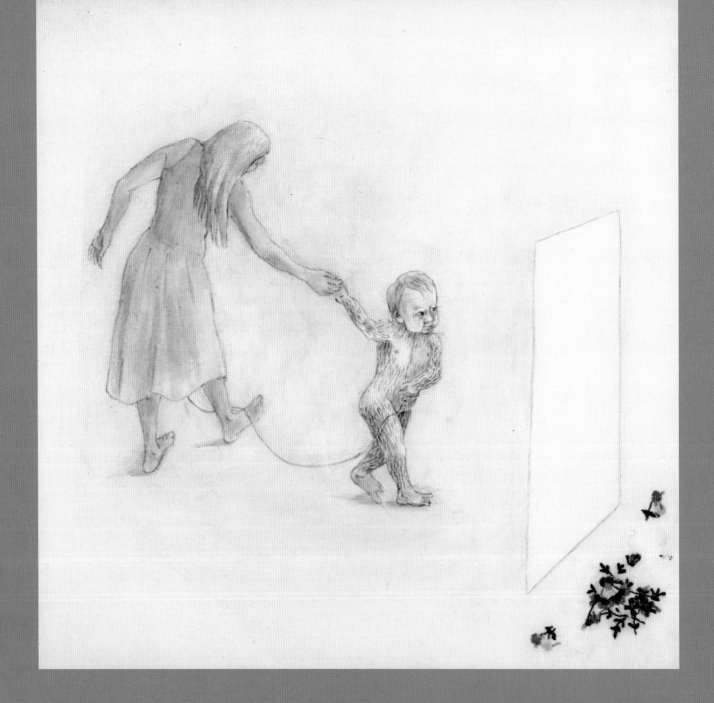

On the fourth day, still attached to his mother by the umbilical cord, the ape-baby crawled down from his mother's belly and stood next to the bed. He peered deep into her eyes. Taking her hand, he urged her up from the bed. Navigating was difficult with her bent neck, but Accalia soon discovered her son was strong and an able guide. The heron swooped under the door frame and led the way out into the hazy sunlight. The umbilical cord trailing between them, the ape-baby and his mother emerged from their cozy den. Just outside the threshold was a landing. The ladder she had climbed three days ago was directly in front of them. However, the ape-baby urged his mother to the left, where there was another ladder, leading down to a pier, and there, stowed under a wooden bench, was a collection of fishing poles and nets.

Accalia sat while her son methodically sorted through the collection until he found a sturdy pole with a great length of strong fishing line wound neatly around its end. He stood and proudly held the pole out to his mother, and fixed her with a knowing gaze. Just then she recalled the cloth bundle stowed in her pocket.

The lure sparkled in the sunlight as Accalia deftly tied it onto the fishing line, the turquoise liquid luminous in the glass vial. The heron sat perched on one lanky leg at the edge of the pier as she tossed it past him into the water. The glowing lure splashed through the algae and slowly sank into the cloudy water. The ape-baby sat snuggled close to his mother on the bench and they patiently waited. After a while there was a tug on the fishing line. It soon became so intense that it lifted the mother off of the bench. Her son and the blue heron grabbed hold of the pole, and together the three of them pulled back with all of their might.

Then something changed. The weight on the other end became a dead weight, and though it was still heavy, it no longer pulled at the line. Together, exhausting the remainder of their strength, they reeled in their catch. Finally something big and dark broke the surface of the water. The three dropped the pole, reached into the water, and hauled the unconscious beast onto the pier. After catching their breath they cautiously examined their catch. The fishing line disappeared into a long reptilian snout with many teeth protruding from the monstrous mouth. The head of the creature rested on an apelike, hairy body. However, her torso was the most unusual: two arms grew from each side, and a multitude of abundant egg-shaped breasts protruded from her chest. Her hands and feet were scaly and webbed, and a biosphere of slimy plants appeared to be growing from her shaggy fur.

Accalia realized that her father's arms were here, inside the gut of this sodden giant, but she was perplexed about how to proceed. While absentmindedly pushing her hair back from her face, her arm brushed against the paintbrush still stowed at her waist. She drew it out and abandoned herself to the familiar feeling of its power. Closing her eyes, she became aware of an image welling up inside. Unable to lift her head, she moved to the edge of the pier, directed her gaze out over the water, and began to paint. Colors flowed from the tip of the brush, brushstrokes built one upon the other, and a disturbing vision began to materialize.

The painting showed a dark tunnel descending from the dripping cavernous opening of the alligator-ape's mouth, and disappearing into the opening was her precious ape-baby. She staggered back from the abhorrent image, as her son pushed up against her, reached up, and consolingly took her hand. She looked down into his soulful eyes and knew that the narrative in her painting would come to pass. Accalia and her helpers pried open the massive jaw. As she stood trembling under the weight of the upper jaw, feeling faint from the stench emanating from its gaping mouth, the blue heron flew away and returned with a stick to prop open the snout.

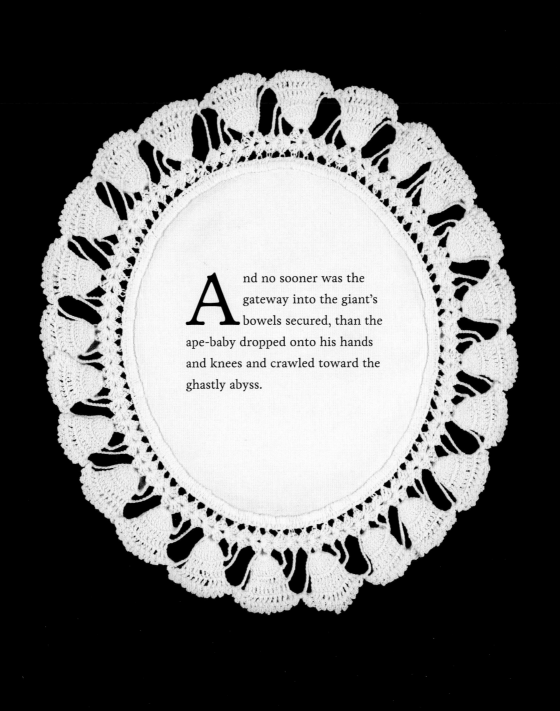

And no sooner was the gateway into the giant's bowels secured, than the ape-baby dropped onto his hands and knees and crawled toward the ghastly abyss.

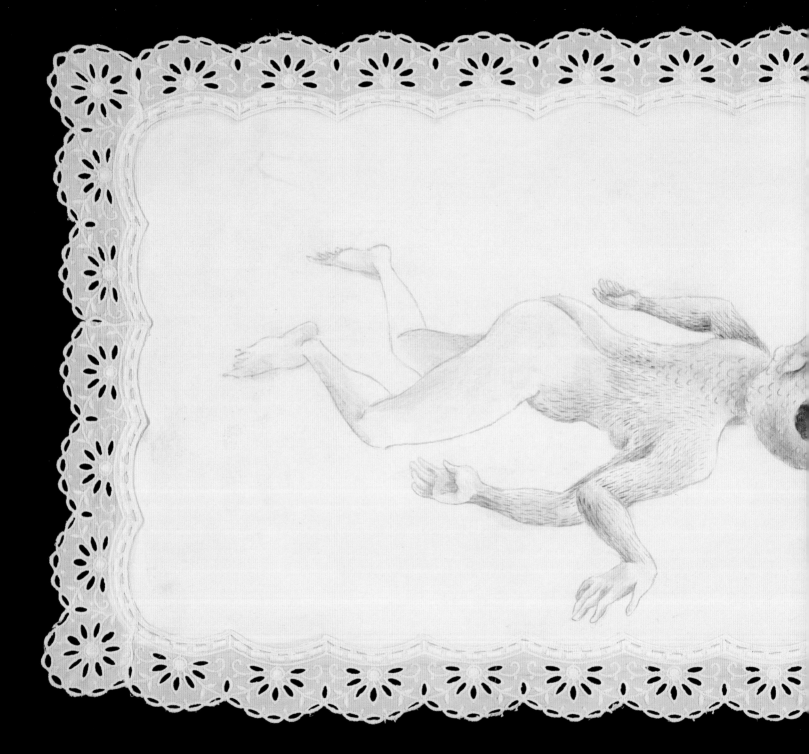

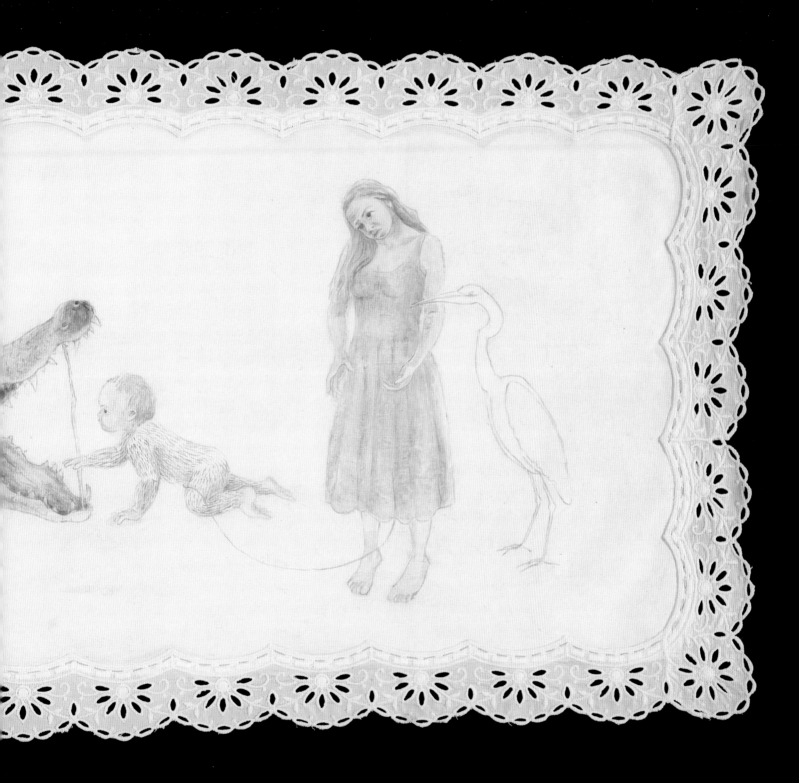

As he passed through the mouth and dropped down into the passage, the young mother's only reassurance was the knowledge that the umbilical cord still bound them. The cord became increasingly taut as the ape-baby drew farther away from his mother and closer to his grandfather's arms. After what seemed like an intolerable amount of time, she felt three distinct yanks on the cord, so she grabbed hold and pulled and pulled until her baby's head emerged from the ape-monster's throat. He slid the rest of the way out, covered in mucus, his tiny hands at his sides, clutching two oblong objects.

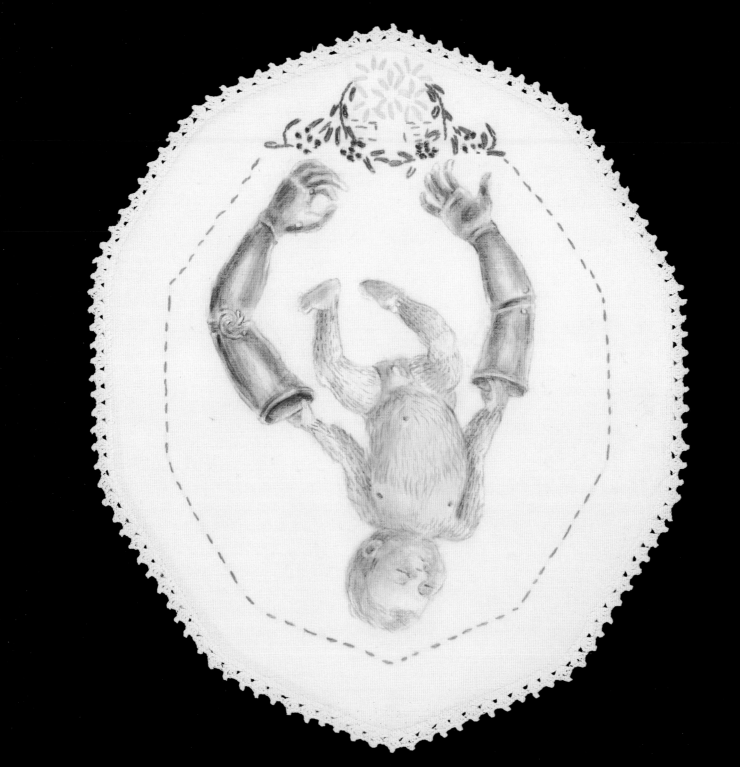

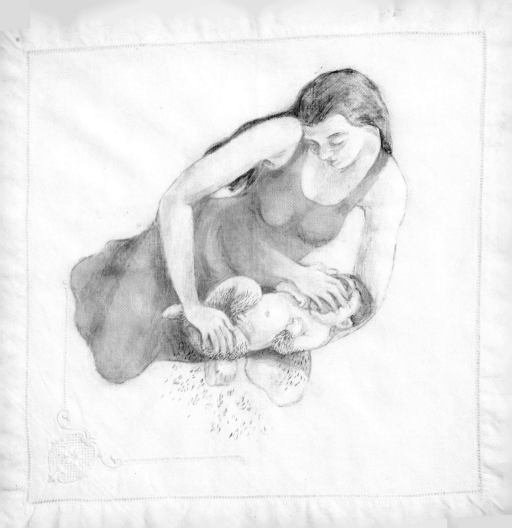

Accalia scooped her child up to her breast and held him tightly. Then, tearing a strip of fabric from the hem of her dress, she sat at the edge of the pier and, dipping the cloth in the water, tenderly wiped away the slimy goo. As she bathed her ape-baby's body, she discovered something peculiar. The cloth was removing not only the mucus; his downy fur was coming off as well, and in that moment she realized that his feet no longer resembled an ape's feet, they were fully human.

A squawk from the blue heron drew their attention. Before him the objects recovered from within the alligator-ape lay glistening in the sunlight, uncannily resembling her father's severed arms. Accalia cautiously lifted one. It was hollow and surprisingly light. As she rubbed the surface with the cloth from her dress it began to shine brilliantly. Her father's arms had metamorphosed from his flesh and blood into a silver metal. Looking up toward the still-gaping mouth of the unconscious beast, she saw the lure, catching the light as it dangled from the roof of its mouth, the glass vial now empty. The silver of the lure was indistinguishable from that of the transformed arms.

The heron and baby boy observed as Accalia worked furiously to clean and buff the surfaces of the arms, bringing them to their full brilliance. Her father's arms were magnificent. They were not made of human flesh, but it was as if they were real, the fingernails incredibly detailed, the joints, easily manipulated. Unable to control the urge, the mother slipped her father's arms on, over her own. And even though they were too big to fit her properly, it was comforting to wear them. A feeling of well-being overcame her, just as she perceived a curious tingling sensation in her neck, as if it had been asleep and was waking up, and before long she could easily lift her head to its full upright position. She began to laugh, standing there, flanked by her beautiful son and blue heron friend, surrounded by the lush forest, dripping with life, the silver jewellike arms, reflected in the water, sending dancing dapples of sparkling light in every direction.

Joyfully she swept her baby boy up, enveloping him in her father's strong embrace. There was a plop on the wooden planks as the dry and shrunken umbilical cord fell at their feet. She bent down and gathered the leathery coil, and then went back to the supine monster and removed the hook still embedded in the flesh of her snout. The young mother swaddled the umbilical cord and the magical lure in the cloth given to her by the fisherman and stowed the bundle in her pocket.

Curled at his mother's feet on the wet wooden planks, the baby boy laid napping contentedly. The alligator-ape lay in repose next to him. She wondered briefly at the startling juxtaposition and then made a decision. Still wearing her father's arms, she lifted the sleeping baby and held him close to her body, careful not to wake him. It took some time for her to negotiate the ladder while cradling a sleeping child, but she eventually made it up and into the cabin, where she placed him on the bed and wrapped her father's arms around him to keep him safe while she prepared for their departure.

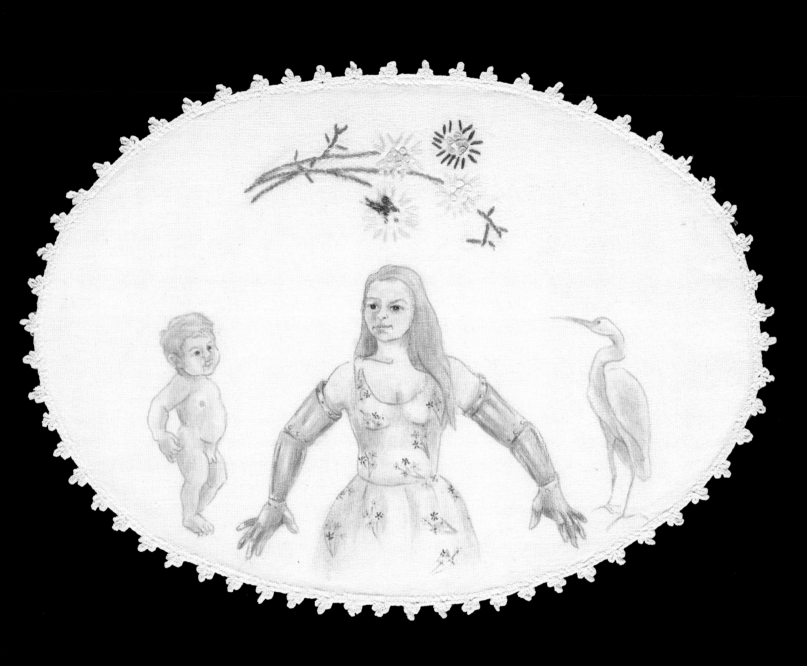

Accalia gathered the mosquito netting, easily pulling it loose from the ceiling, and carried it down to the waiting pirogue to arrange it into a soft bed at the bottom. Back in the cabin, she collected the remaining food and, looking around, spotted the coffee pot, which she filled with fresh rain water from a barrel outside the door. After packing the boat, she returned to the fishing pier to face her final formidable task. However, she was bewildered to find the platform bare, a wet stain the only remaining sign of the creature that recently laid there.

She had to adjust herself to this new state of things, but she soon recovered her senses and hurried to get the journey underway. Before long they were ready to depart. The baby and her father's arms snug at the bottom of the boat, the heron gliding in circles overhead. The young mother stood on the bow, enjoying the gentle rocking, and closed her eyes. Just then a feeling of excitement overtook her and she suddenly felt an intense urge to paint, so she grabbed the pale-blue handle and, brandishing the brush, unleashed its prophesy.

The space in the image presently hovering over the water was ambiguous and very unlike the more realistic places of the previous paintings. Here two separate iconic illustrations floated one above the other. In the top half of the picture plane was a cottage, barely visible beneath overgrown vines and weeds. Below it the alligator-ape creature floated among other freshwater animals, appearing omniscient and otherworldly. As the enigmatic pictures became fainter the heron took off on a course for home, the young mother with her precious cargo following behind.

As dusk approached, the shadows of the forest stretched over glasslike surfaces. The repetitive sound of the oar being pulled through the water created a rhythm, keeping time with a nocturnal cacophony, until in the distance there could be heard another kind of music. As the sounds drew closer, the young mother recognized the bridge she had crossed to the ape-oracle island, silvery and ethereal in the encroaching moonlight. As they floated silently by, Accalia could see dancing figures illuminated by firelight flickering through the trees. There was a feeling of celebration in the air, but she continued on, anxious now to return home.

Through the night Accalia paddled, ignoring her aching muscles, pausing only briefly to check on her baby, and seeing the rise and fall of his tiny abdomen in the moonlight, she continued to row, the little boat leaving a wake in the smooth dark water. Once in a while the hairs on the back of her neck prickled as an uneasy feeling passed over her,

a sense that some other presence was close by. Twice she caught a glimpse of an ominous shape moving under the water next to the little boat, but much to her relief, nothing ever materialized. Up ahead she kept in her sight the tirelessly flapping wings of the blue heron, silhouetted against the luminous night sky. Through her bleary eyes it sometimes looked like her mother, the lioness, flying in the distance, leading them out of the swamp.

The lonely sound of a solitary birdcall pierced the silence of night. It was soon joined by others, singing praises to the coming dawn as a faint light languidly rose up from the ground. As the boat emerged from the last tributary and into the bayou, the baby began to stir. Accalia gratefully hugged his warm chubby body and he suckled contentedly while the boat floated into the open water. When the baby seemed satisfied she sat him on the seat between her legs, freeing her arms for the final paddle strokes. Before long, she spied the fisherman, hunched over his lures in the pirogue as before. They pulled up alongside him, and he looked up with a wise smile as her boat gently nudged his.

She nervously removed the bundle from her dress pocket, set aside the umbilical cord for safe keeping, and offered it to up him, but the fisherman shook his head. "The lure is yours to keep. You've earned it." Bashfully, she lowered her eyes and thanked him. When she looked up again, he was back at work, his leathery hands moving with grace and certainty.

She stuck the paddle into the mud bottom and pulled the boat through shallow water and up onto dry land. A quiet thump from behind caused her to look back just in time to see the blue heron land next to the fisherman, who reminded Accailia of the fish-messenger from her yard. Suddenly from the corner of her eye, she saw a large shadow moving away just under the surface of the water, but it disappeared before she could see it clearly. When her gaze returned to the pirogue, Accalia was not surprised to discover the fisherman's elderly human face where she thought she saw the fish's just a moment before. Sadly, in that instant, she realized that her blue heron companion would be staying here with the fisherman. "Farewell my friend. I will miss you. I hope to see you again someday." The blue heron flapped his broad wings and squawked in response, and Accalia turned back toward the journey that lay ahead.

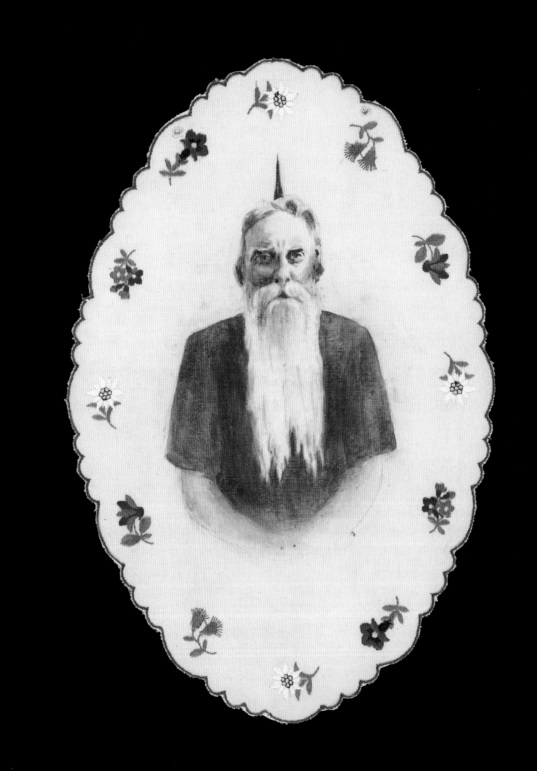

Using the mosquito netting as a sling, Accalia secured the baby onto her back, making it possible to easily carry her father's silver arms as well, and after she drank the remainder of the water from the coffee pot, they set off, backtracking along the path that led her to this place just a few days before. The baby squealed with delight at the dangling moss that lightly caressed the top of his head. Accalia smiled to herself as she navigated along the path. Finally, up ahead, the sunlight appeared to brighten as the trail left the swampy forest and revealed the paved road. Stopping for a brief rest, she laid the silver arms on the ground, mopped the sweat from her face with the hem of her dress, and readjusted the sling which had slackened from the baby's excited squirms. Almost instinctively, Accalia pulled on her father's silver arms, as if they were gloves, significantly lightening her burden and reinvigorating her for the final stretch home.

In the heat of the day, the sun beat down on the desolate road ahead. As familiar landmarks began to appear, Accalia walked faster, eager to see her family and to present the resurrected arms to her father. Before long, in the distance, she could just see her yard, but as she got closer, it became apparent that something was wrong. The grass was tall and dead, and matted weeds had taken over the flowerbeds. But the most shocking sight was the house itself, which had become engulfed by wild vines. It was the iconic image from her last painting come to life. Terrified for the fate of her father and sisters, Accalia ran to the house, and with the added strength of her father's arms, wrestled the growth away from the windows. With great difficulty she eventually exposed the choked doorway.

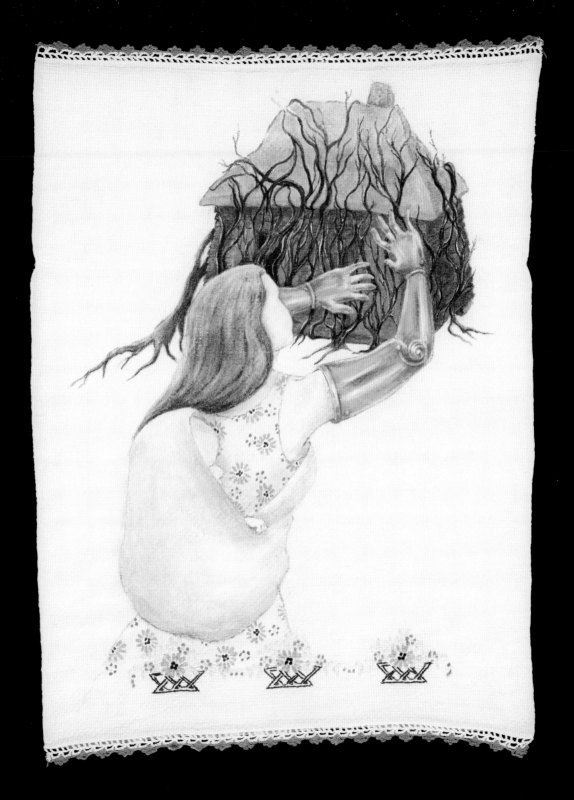

Her heart pounding, Accalia slowly opened the door. Inside it was quiet and dark. Filtered light from the partially uncovered windows revealed familiar surroundings, but everything was in disarray and covered with a layer of dust. As they crossed the threshold, the baby began to wake, and then, she saw them. Her father and sisters were huddled together in the cavelike space under the kitchen table. She turned on a lamp and moved closer. At first it appeared as if a spider's web had woven the three of them together, but then she realized it was matted strands of her two sisters' long blond hair, tangled and strewn around their bodies. If she hadn't detected shallow breathing, she would have assumed they were dead. They were blanketed in dust and appeared to be in a deep sleep.

Hoping not to startle them, Accailia bent down and whispered, "Father, wake up," but there was no response.

Unbinding the baby from the sling, she placed him on the floor, crouched down, and nudged her father and sisters. Finally her father began to stir. His eyelids moved and with great effort he pried his eyes open.

When he was able to focus, her father cried out in a croaky voice, "You're home! Accalia! Is it really you? Your face . . ."

"Yes Father, I'm home. . . . I have something for you . . ."

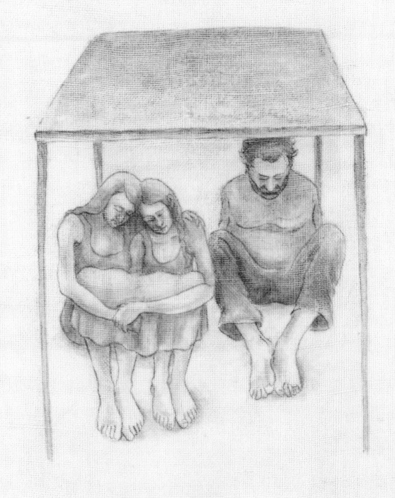

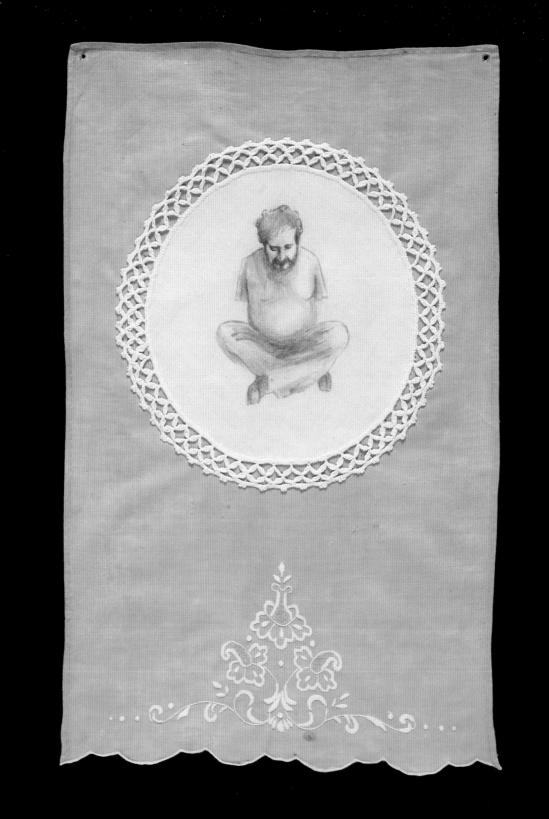

However, he was now looking past her, his rapt attention focused on his grandson, who sat before them cooing sweetly. Accalia crawled in to help her father. Lucilla and Lunetta, still in a deep slumber, hadn't yet stirred, and as Accalia drew closer, the hair on the back of her neck bristled. She found it hard to breathe, willing herself not to think the unthinkable, as the realization that her sisters might not wake dawned on her. She turned to her father who was very weak and needed her.

It seemed to Accalia like ages had passed since she dressed her father's gruesome injuries. She had done her best to patch the holes where his arms had once been. Now dried, brownish blood caked the dirty bandages. Crusted spots spattered down his clothes and onto the floor. Accalia squeamishly removed the gauze, afraid to see the state of his wounds, but was relieved to find that the stumps had healed well. Until that moment, she had forgotten that she was still wearing her father's rescued arms, so she ceremoniously removed them and held them up for him to see. Even in the dim lamp light, the silver arms gleamed; her father was overtaken with emotion. Unsure about how to affix the arms properly, she gingerly placed them over his stumps. The silver arms seemed to magically connect to his flesh, instantly becoming natural extensions of his body.

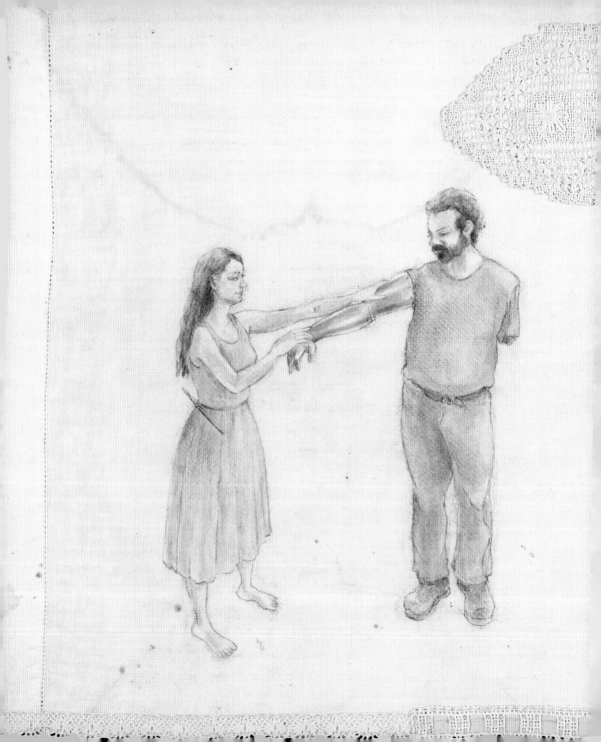

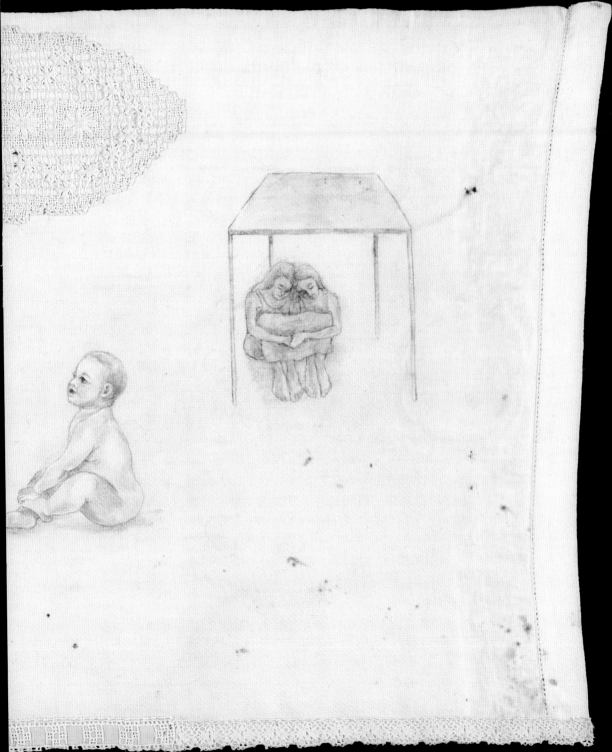

With renewed vigor her father came out of his hiding place, took his eldest daughter into his new arms and held her. Then he lifted his grandson and the three clutched each other tightly for a brief moment of peace.

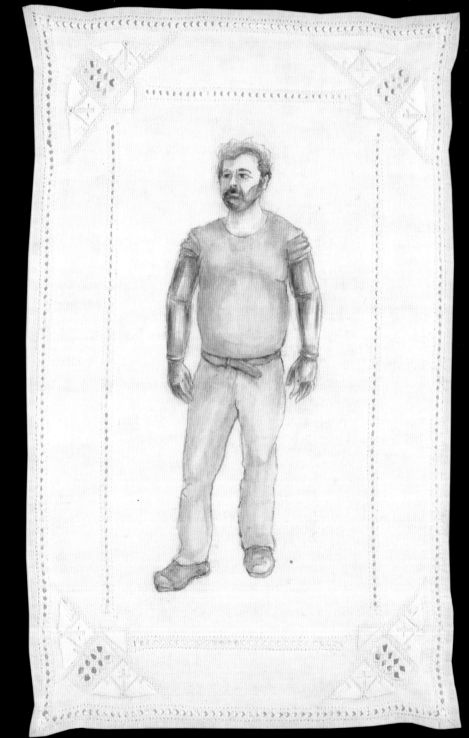

But Lucilla and Lunetta remained entwined and deathly still. They could not be brought back to life. Accalia and her father stoically concentrated on the task at hand. To avoid attracting evil spirits, crying would have to wait until after the body was laid out. Using four chairs from the kitchen table and a large plank of wood from the shed, they created a bier and covered it with a white sheet. There they laid Lucilla and Lunetta, making sure to place their feet facing the door. The burden of preparing her sisters' bodies fell upon Accalia, now the only woman left in the household. Father left the room to care for his grandson.

Silence descended.

Accalia ceremoniously undressed her sisters. Their conjoined body shone luminous on the white sheet. She stared in awe at the beauty of their perfect symmetrical form. Lucilla and Lunetta had always been modest and took great care to conceal their joined parts, so Accalia hadn't seen them nude since they were young children. Struggling to hold back a torrent of tears, she labored on, lovingly bathing her sisters and anointing their joined body with fragrant oils. From the bottom of the old cedar hope chest, shared by the three sisters, Accalia brought forth Lucilla and Lunetta's wedding dress. While dreaming of an enchanted future, the twins had labored many hours over the flowing white garment. Now eternally clothed in their wedding gown, Lucilla and Lunetta lay together peaceful, as if asleep.

Accalia loosened her sisters' golden braids to ease the movement of their souls, and snipped a tress of hair from each. Finally, she could mourn. She wept and wept as she pulled from her pocket locks of hair collected from her father, her son, and herself, and began the intricate work of weaving three generations of hair together into a circular wreath.

At some point, Accalia drifted off and dreamed of their mother. The lioness stood over her departed daughters pitifully crying out with a mournful roar.

Accalia shivered and woke with a start when a breeze blew in through the open window. She was confused, certain it was closed earlier, and as she reached to shut it, a spray of golden hairs on the windowsill caught her eye. In vain she squinted into the dark night sky, but saw only blackness. She gathered the hairs from the sill to weave into the family wreath, and closed the window tight.

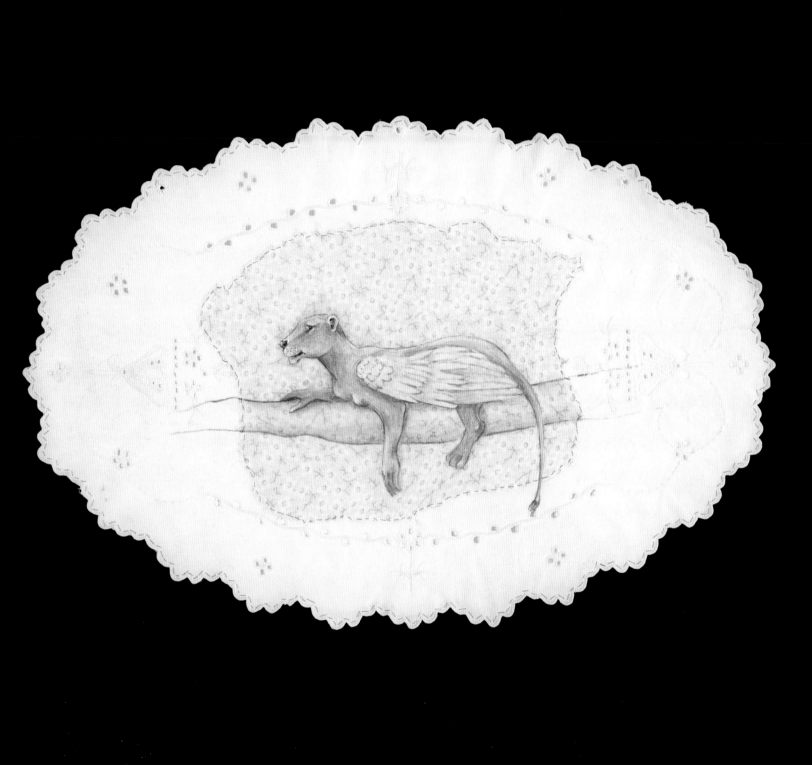

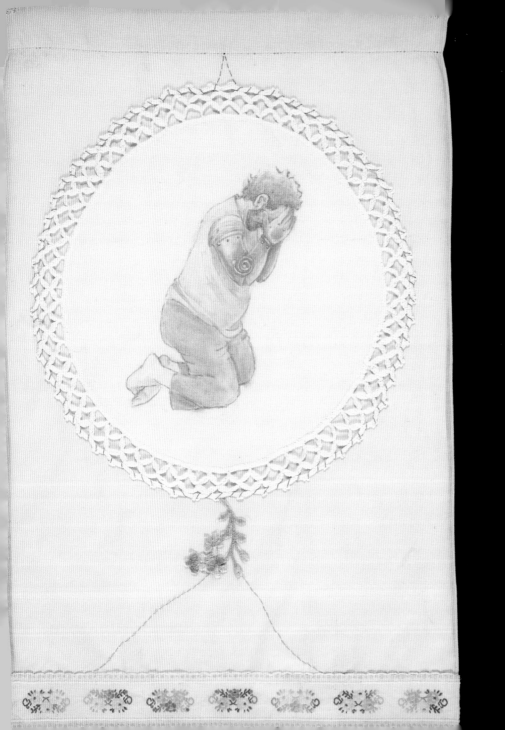

After a while, Father came to relieve her. Kneeling beside the bier, he grasped his daughters' pale hands with his strong silver fingers. On bended knee, he sobbed a deluge of regret and sorrow, whimpering endless apologies, begging for atonement. Finally, when everything had fallen away, he stood and embraced his daughters. With his magical silver arms, he held them and loved them, refusing to let go or give up. Before long he felt something stir. Lucilla and Lunetta awoke.

The baby had just fallen asleep when Accailia heard her father cry out. Upon entering the mourning room she was stunned to find her sisters miraculously sitting up and smiling as if they shared some secret understanding.

In unison, they said to Accalia, "Sister, bring the scissors."

Bewildered, Accalia ran at once to retrieve the scissors from the sewing basket. When she returned Lucilla and Lunetta were standing and holding their wedding gown at the waist, pulling the fabric taut, away from their torsos. They instructed their older sister to make a small cut in the front and the back. Together the conjoined twins tore their dress in two, and then, gazing into each other's eyes, stepped away in opposite directions, separating from one another.

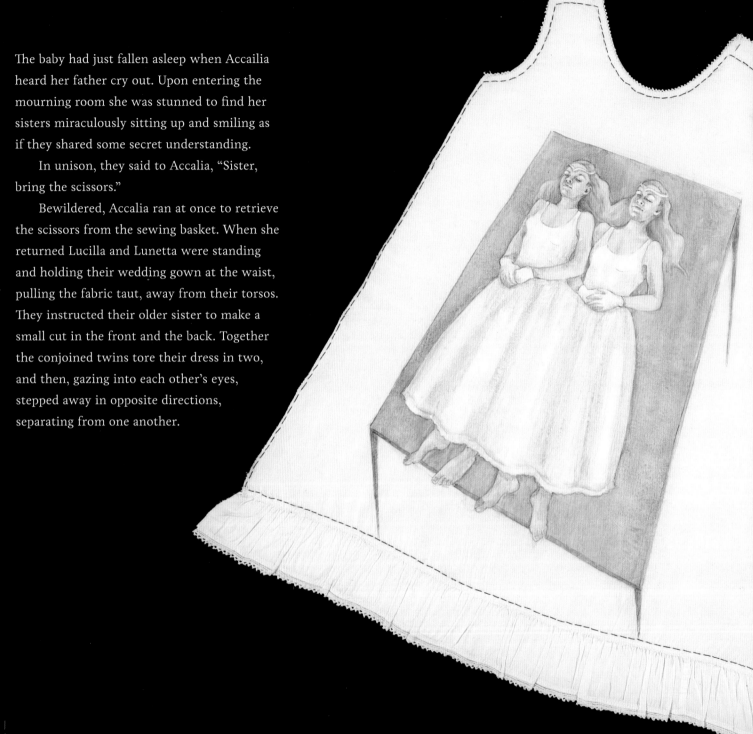

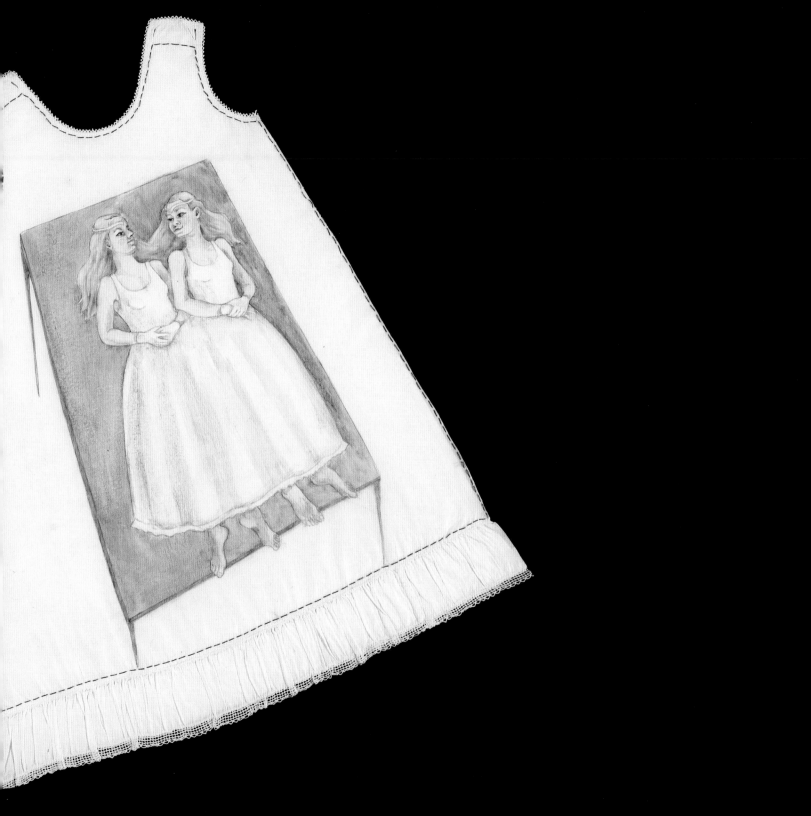

The afternoon sun shone through the windows and glinted off of Grandfather's silver arms. The two aunts observed from opposite sides of the room as he frolicked on the hearth rug with his grandson, who was delighted by the sparkly display. Unnoticed, Accalia slipped into the bedroom, removed the cloth bundle from its hiding place under the mattress, and placed it into her dress pocket. She checked to make sure her paintbrush was secure at her waist, where she always kept it now, and snuck out into the backyard, hoping not to disturb their play.

It was a gorgeous day with a crisp blue sky and warm gentle breeze. The grass tickled her bare feet as she made her way across the yard. Accalia knelt and pushed aside the stone at the foot of the crepe myrtle. She'd felt compelled to return to this spot since arriving back home. The fragrant earth collected beneath her fingernails as she dug, until they scraped the lid of the wooden box. She pulled it from its burial place and brushed away the loose dirt.

Prepared for the stench of decaying flesh, Accalia hesitantly opened the tiny coffin. However, it was empty; no sign of the fish remained. So she set the open box on the ground and retrieved the bundle from her pocket, pulling back the fabric to expose the treasures inside. Resting side by side, the two objects appeared to be in stark contrast to one another, the crystal and silver lure shimmering beside the withered umbilical cord. However, in her mind the two relics would always be linked.

Using the cloth from the old fisherman to line the box, she gently nestled the precious mementos inside and closed the lid. She then lowered the box into the earth, covered it with the loose soil and patted it down, making sure the dirt was securely packed. Feeling content, she moved the stone back into place and sauntered to the center of her back yard. The wind blew her hair back as she withdrew the paintbrush from its holster. With her feet firmly planted to the ground Accalia tilted her face to the warm sun, closed her eyes, and waited for inspiration to come.

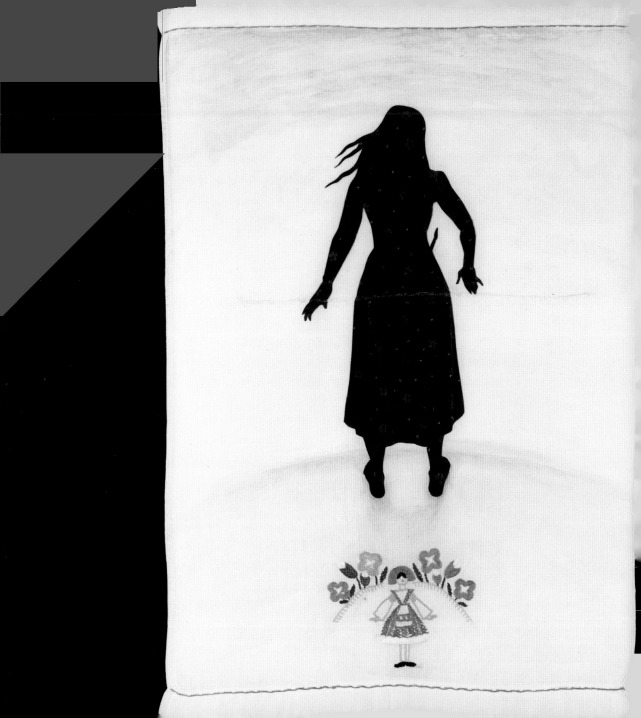

# Insights *and* Interpretations

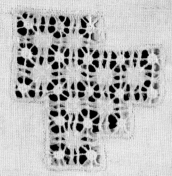

# Beneath Antique Lace Moons

SARAH BONNER

When Kelli Scott Kelley wrote *Accalia and the Swamp Monster* she joined a historical trajectory of female story-tellers that can be traced back to mythical Philomela, who communicated her fate by weaving her tale into a tapestry. This tradition continued with Scheherazade of the Arabian Nights, with Marie-Catherine d'Aulnoy and Marie-Jeanne L'Heretier of seventeenth-century French literary salons, and into the twentieth century and writers such as Angela Carter. With *Accalia*, Kelley has become a wise woman, a *sage femme*—a literary midwife of our time, delivering a glimpse of cultural truths whereby young girls are brave, independent, and strike out on journeys in order to discover themselves and to protect their families. Embarking on such a journey, Accalia takes on the task of safeguarding her family and in the process matures from girlhood to womanhood. On her trek she is fearless and proceeds with intelligence and intuition. The tale reminds us of the qualities of independence, integrity, and boldness practiced by young women in the twenty-first century.

The central protagonist, Accalia, follows in the footsteps of many well-known fairy tale heroines; sacrificing herself for the benefit of her father brings to mind *Beauty and the Beast*, the tasks and journeys undertaken recall *Cinderella* and *Snow White*, even the somnambulant state of her family and their cottage when she returns has an echo of *Sleeping Beauty*. However, Accalia's role is less the persecuted heroine made familiar through Disney versions of popular European tales. Accalia does not subscribe to commonly held fairy tale feminine ideals of physical beauty or passivity but is instead a strong-willed and determined heroine. Her ancestral heritage can be found in Greek and Roman mythology in the goddesses of childbirth and virginity, Artemis and Diana. Diana the huntress, particularly, is a convincing predecessor for Accalia, as the former is fabled to have had a split personality: on one side she is pure and virginal and on the other side she is arrogant and vengeful. Kelley has worked both of these aspects into Accalia's two dog heads while also alluding to an immaculate conception. This and the reconciliation of her personalities indicates the process of her maturation. Accalia completes her task with candor. In this tale there is no prince to save the day—nor is one necessary.

Traditional fairy tales often chart the rites of passage from adolescence to womanhood, and Accalia too undertakes this journey. However, in Accalia we perceive female action rather than inaction, a role reversal of the traditional

and popular fairy tale heroine. Far removed from her for-mulaic Disney cousins, Accalia is more closely related to the heroine of *Donkeyskin*, a lesser-known European fairy tale. The protagonist in that tale, under duress to marry her father, gives up her life of riches and status in order to remove herself from the potential union. Through this posi-tive act the heroine saves herself and her father from his mania. Accalia, too, acts to save her father by undertaking a journey to recover his arms. The heroine of *Donkeyskin* disguises herself with the pelt of a donkey, in a similar way Accalia is also disguised by her two dog heads. Donkeyskin is rewarded by being reinstated to the position she gave up, and Accalia is rewarded by having her two dog heads become a single human head.

Two of the most significant themes of *Accalia and the Swamp Monster* are that of maternity and motherhood. In an echo of traditional fairy tales, the absent mother, the (wicked) stepmother and the virgin (potential) mother are all found in *Accalia*. In this tale the roles are played out by the winged lioness, Accalia's mother, the swamp monster, and Accalia herself. This triad of maternal characters creates a tension in the tale. Accalia's mother absents herself early in the narrative, taking with her the arms of her deceitful husband. Despite her absence, the winged lioness neverthe-less echoes throughout as a glimpsed protective force. The swamp monster is presented as a vengeful matriarch, a terrible beast with a blood lust, yet as the tale unfolds the swamp monster is soothed and she too follows Accalia on her return journey through the swamp. The two mother figures seem to protect Accalia, guiding her almost to her fulfillment of womanhood, as signified by her pregnancy

and with this her true human form. With Accalia, the tem-pestuous mother figures are quieted somehow and joined in guardianship of the virgin mother. Indeed, one reading of the artwork *From the Depths* (pages 6–7) suggests a relation-ship between the lion-mother and the swamp monster. Here, Kelley depicts the scene whereby the winged lion drops the father's arms into the swamp to be eaten by the swamp monster. In this work the subtext is less the re-moval of the burdensome husband and more the sense of alliance between the two female characters.

Many aspects of Kelley's works allude to the feminine and to the female practice of making/creating and, in turn, the process of becoming feminine. One of the most striking aspects of this collection of art is her practice of working on found fabrics. These vintage fabrics contribute a sense not only of history but, specifically, of female history. The fabrics used by Kelley resonate with female skill and prac-tices, often made collaboratively or at least in the company of other women, and belong to domestic and family life. Girls would be taught by older women of the family or community the skills of weaving, spinning, or stitching in their preparation to become a wife and mother. In short, girls would be taught the skills of domesticity and woman-hood. This communal and ritualistic practice would have been accompanied by tale telling, the tellers often being cultural narrators, matchmakers, social judge and con-science (oftentimes described as being a gossip) of a chang-ing society, guiding and informing young girls of their life role through tales.

Appropriated and reworked as the backdrop for *Accalia* artworks, the sense of feminine practice woven into these

fabrics is pervasive. In addition to appropriating these fabrics, Kelley often adds to them. Frequently this is in the form of a stitched line looping through the scene she depicts. In this simple gesture she alludes to the narrative progress of the tale, domestic practice, and the historical—and specifically in relation to the fabrics—feminine process of tale telling more broadly. These themes of feminine skill and of tale telling weave together and are echoed in the narrative of the images that are drawn, painted, applied, or stitched onto the fabric.

Through images that are lightly rendered and carefully detailed, we are introduced to the main characters of the tale as well as to the narrative development. The protagonists are given their own portraits and, significantly, the three mothers—Accalia, the winged lion, and the swamp monster—have several portraits dedicated to them. Otherwise, the artworks are narrative sequences that exist somewhere between theatrical tableau and descriptive imagery such as the work *Rampage* (pages 40–41) and *Once Upon a Time* (pages 4–5). Some images adhere closely to specific plot developments and are therefore important semiotic signposts, whereas others are less specific. However, the body of work must be taken as a whole to gain the full flavor of the tale depicted.

In the 2011 piece *Odyssey* (pages 46–47), Kelley depicts the scene where Accalia paddles the pirogue following the blue heron who guides her. In pursuit, so it seems, the swamp monster follows beneath the surface of the water. The initial feeling evoked is one of unease as one of Accalia's dog heads looks to the heron and the other,

unseeing, looks in the direction of the swamp monster. However, an alternative reading of this image dilutes the disquiet of this work. The trio travel beneath antique lace moons linked by a single blue thread giving a sense of time passing and of stillness as the blue line becomes an additional frame to the image. The framing device used here brings a sense of union to the three figures where Accalia is flanked by guide and guardian.

The overall sense of the narrative is that of a process completed; the heroine returns from her journey a changed woman, fully assimilated into her maternal, indeed matriarchal, role. Taken at face value, Accalia acts on behalf of her father adhering to traditional fairy tale gender and familial relations. But below the surface, and in place of abandonment and threat from the other female protagonists, there is guardianship and alliance. In this body of work meaning is elusive. Kelley works in layers of narrative, contributing her own tale to fabrics that already hold a history. In the end, Accalia returns to domesticity and an ostensibly traditional female position. However, through her actions she has safeguarded her family and resisted predictable passivity in awaiting a passing Prince Charming. In this act of independence Accalia can be marked out as a contemporary fairy tale heroine.

SARAH BONNER is a lecturer of art historical and visual culture at the University of Cumbria. Her research examines the visual resurgence of fairy tales in contemporary art and popular culture.

# A Depth Psychology Perspective

CONTSTANCE ROMERO

*Accalia and the Swamp Monster* by Kelli Scott Kelley is an invitation to enter into an original, numinous world and take a journey of initiation with its heroine. Part fairy tale, part shamanic ritual, the story makes one feel rather like Alice having tumbled down the rabbit hole. However, instead of falling into a landscape reminiscent of Old Europe, the mythopoetic vision that Kelley evokes is distinctly inspired by the swamps of southern Louisiana. We are drawn down into the muddy earth, up into the moss-draped trees, and into the hearts of its inhabitants as Accalia holsters up her paintbrush and paddles down a lost bayou.

Seductive, eerie, and dangerous, Kelley's swamp and its inhabitants teem with the paradoxical life force of the deep unconscious (nature at its most elemental) that can devour one as easily as it might facilitate a rebirth. It is a strange and beautiful landscape alive with Helene Cixous's notion of *jouissance*—that primal, feminine energy with the potential to heal and transform a woman. This jouissance animates Kelley's dreamlike images and calls up the universal experience of coping with what we are born into and what we might become as a result.

While a psychological point of view can never fully plumb the mysteries of a work of art, *Accalia* presents the participant with many intriguing possibilities. The images and narrative speak to a distinctly feminine process of maturation. They also give us a rich template of the making of an artist and her relationship to the world. Another, more personalized avenue of exploration might view all the characters as embodiments of a single personality. From this perspective, each character can be read as aspects of oneself to be reconciled, developed, or let go. Conversely, one can lean into the soundings Kelley appears to be taking at a familial or collective level. From this approach, the tale may be alluding to the development of a more receptive and respectful stance toward that which is Other and the environment. This possibility is seen in the paradoxical condition of the swamp itself: an endangered yet fully formed world, possessing its own wisdom and ethic.

There is an arresting alchemy of word and image in *Accalia* that stirs the memory as it moves us both forward and backward in time. There are threads of current events interwoven with aspects of a bygone era. The hurricane that changes the natural order of the swamp echoes the damage wrought by Katrina on Louisiana's wildlife and wetlands. This modern catastrophe is juxtaposed with Accalia's ritual preparation of her sisters' bodies for burial,

which provides a direct link with ancestral feminine traditions within Acadian (Cajun) culture. Likewise, the old Cajun fisherman crafting his lures harks back to days gone by, both as a source of deep inspiration and as a reference to the tragedy of the Acadian diaspora. The theme of diaspora is also prevalent in the tale through the near extinction of the swamp apes. Here the encroachment of the human species on the natural order serves as a reminder of the precarious state of the Gulf Coast ecosystem and the recent plight of animals during the BP oil spill.

The numinous quality that *Accalia* exudes, like all fairy tales and shamanic journeys, signals the presence of an archetype; one senses a theme or motif both other-worldly and inexplicable but nonetheless makes itself felt. This uncanny emotional quality is evidenced by Accalia's shivers of premonition and her willingness to surrender to her intuition. She knows to trust the scenes her paintbrush spontaneously creates, but, more importantly, she also knows how to suspend a dominant rational orientation and let go into the space of myth making. Fortunately, in Accalia's case, it is not the old familiar myth of the conquering hero but one for a modern psyche that seeks to balance itself with a more receptive and dialogic orientation. Instead of heroically slaying a dragon, Accalia and her newborn child carefully and respectfully gain entrance into the belly of the beast. Once inside, they retrieve what is needed and leave the swamp monster, allowing it to return to its rightful place in the psychic landscape—the depths. This is more akin to the shaman's way, which respects nature and does not seek to dominate the natural order so much as to find a way to live sustainably with it.

The themes of death and rebirth, childbirth and motherhood in *Accalia* all point to the presence of the Great Mother archetype. The swamp monster, the winged lioness, and the ape-oracle all emanate aspects of the Great Mother and have their origins in numerous mythic predecessors. The swamp monster and the winged lioness, in particular, call up the mythic Furies of Aeschylus' *Oresteia*. These ancient female deities, scorned and denied by a more Apollonian rational approach, stalk our psychic reaches, waiting for recognition of their repressed, devalued condition. A depth psychology perspective suggests that getting in touch with these inner states requires a period of reflection apart from our normal routine, where repressed rage and grief may be touched. We need to remove, as Accalia does, into another realm that is more attuned to the rhythms of the unconscious and feminine ritual, where these primal feelings can be held and transformed. Like Ereshkigal, the Sumerian queen of the underworld, or the Greek Medusa, the swamp monster and the winged lioness represent images of a divine feminine natural force that seeks redemption within and through the human psyche. There can be little sense of inner wholeness without bringing the Dark Goddess, the Witch, the Bitch, or the Wicked Stepmother into further consciousness within ourselves. Such awareness is vital for maturation as minorities, women, animals, and nature have traditionally been designated; they are the carriers of these archetypes created by the dominant culture and, as a result, they have been repressed. This repression may account for their return in our dreams and unconscious moods.

Kelley's story telling combined with her delicate yet dynamic images (many placed on antique recycled fabrics or her son's school lesson papers) provide stopping-off places for reflection along the heroine's journey. These domestic materials underscore not only the bedrock of feminine ritual in the story, but they also anchor us to the familiar as we strike out with Accalia into the unknown. One such stopping-off place, which is reminiscent of a Victorian era cameo, is the arresting portrait of the ape-oracle. Subtly humorous, strange, and comforting, the ape-oracle evokes the nurturant animal nature of all mothers and grandmothers. More primal than a fairy godmother, the ape-oracle is a reminder of the sacredness of the animal nature in ourselves with its capacity to heal. The ape-oracle also echoes her Greek predecessor, the Oracle of Delphi, seated on her tripod as she breathes the mind-altering vapors that arise from a crack in the earth. This ancient shamanic practice, customarily performed by women, enables the ape-oracle to see how and when Accalia may find her father's lost arms. Again, Kelley points to the primal power of nature as Accalia listens to the oracle, accepts her talisman, and then views the flames of natural gas dancing on the surface of the swamp.

The images of Accalia's two dog faces, her sisters conjoined bodies, their lioness mother, and dismembered father alert us to the fact that the family is bewitched. Read psychologically, this scenario might represent states of mind overtaken by the energies of the unconscious. The humanity of the family members has been replaced by a situation of mythic or archetypal proportion no longer humanly endurable by its participants. Rather, Accalia's siblings are enmeshed, her mother violent, and her father so paralyzed by guilt that he is incapable of caring for himself or others. To bring things back into a state where human relationships can flourish, Accalia, in true fairy tale fashion, must undergo a series of trials. These tests are needed in order to engender her capacity for motherhood and her life as an artist, both of which could be seriously hampered if she remained passive about her circumstances.

The birth of the Divine Child, who is able to retrieve the father's arms before they are completely devoured, may be said to symbolize Accalia's capacity to gain the treasure that was lost but is now regained through a relationship with the deep unconscious. Here the newly minted silver arms, alchemically transformed in the belly of the beast, serve as a metaphor for the capacity to descend into the depths, relate with humility to the images and experiences that arise, and return with a new orientation. Accalia comes back from her journey not a conquering hero but a relational human being who has learned to savor her life as a mother, sister, and daughter. She has also gained the ability to aid those she loves. She has become fully human and is no longer split between feelings of fear or aggression. Instead, she becomes her own father by taking up the new silver arms, and her own mother, as she births her precocious child nature. In doing so she relies on ancient feminine wisdom to guide herself and her family into the future. Led by the heron and the apes, and guarded by the lioness and the crocodile mother, Accalia shows us that, by becoming aware of our animal nature rather than unconsciously acting it out or repressing it, we may become more fully human. Like a shaman or alchemist, Accalia must

listen with her feelings and not her intellect. This approach is very different from a more rational orientation and unsettling to the conscious ego. Journeys such as St. John's "Dark Night of the Soul," Jonah's time in the belly of the whale, and Dorothy's trip to Oz speak to the sense of alienation or terror we may feel in times of trauma or depression. We want to live, grow, and change, but we have no idea what to do or what this might look like. In the tale, Accalia trusts feminine ritual, the natural world, and, most importantly, her imagination. It is this creative ability that heals as it engenders the capacity for symbolization. She shows us that finding words and images for that which was previously overwhelming and unspeakable can transform our world, both inside and out.

CONSTANCE EVANS ROMERO, LPC, LMFT, is a Jungian analyst in private practice in Mandeville, Louisiana. She is also a training analyst for the Inter-Regional Society of Jungian Analysts, the New Orleans Jung Seminar, and The Florida Association of Jungian Analysts. She lecturers nationally on the interface between art and depth psychology and is the founder of the Archetypal Theatre Company. Her memoir, *The Cane is Crying: Notes on Katrina*, was published in *Psychological Perspectives*, 49, 2006.

# Acknowledgments

Many people have encouraged and assisted me throughout the evolution of this story and body of work. Words cannot express my gratitude for my mother, Gladys Runnels, the artist, musician, and poet. Thank you for opening up the possibilities of the creative life to me at an early age. Thank you to my stepfather, Kelly, for showing me the love of a "real" father. I am grateful for my sisters, Robbi and Cindy, fellow travelers on the rocky road of our childhood. Thank you for providing me with inspiration for this story. Gretchen, my lifelong friend, thank you for being the first person I trusted to read this story, for your encouragement and advice. Jacquie, I so appreciate our walks imbued with rich discussions. Thank you for inspiring me with your words and work. Thank you my Sacred Sisters for your love and support, especially to Julie for being an early editor of this story. I want to express my sincere gratitude to Pat Godfrey for starting me on this journey. Fabian, I cherish your constantly seeking mind. Thank you for helping me to see the magic paintbrush. I am so indebted to Margaret, Pat, and Darlene for giving me your precious family linens to transform into these artworks. To my models—Greg, Dennis, Ruby, Madeline and Allison, and most of all, my beautiful niece Sage—thank you for allowing me to use your image to create these characters.

Rod Parker, I am grateful for your "open door." I thank Kevin Duffy and David Humphreys for the art reproductions in this book. Kevin, thank you for photographing my art all these years and for always saying "yes," regardless of how tight the deadline. Thank you Geri Hooks, Mark Tullos, and Joy Glidden for your support. My sincere thanks goes to Jordana Pomeroy and Natalie Mault for giving me the opportunity to open the *Accalia and the Swamp Monster* exhibit at the LSU Museum of Art. Support from the Louisiana Board of Regents Support Fund, Award to Louisiana Artists and Scholars (ATLAS) allowed me to bring this work to completion. To everyone at LSU Press, I want to thank you for making this book possible. Rand Dotson, I so appreciate your initial interest in this work and all of your assistance through this process. Neal Novak, thank you for your insightful editing.

I dedicate this book to Finnian and Bill. To my son, Finn, I cherish your awesome imagination. Thank you for reminding me that there is wonder and magic in the world. To my husband, Bill, my fairy-tale knight in shining armor, my deepest gratitude. Thank you for always being there, for your undying love and companionship, and for believing in me.